Lives of Titian

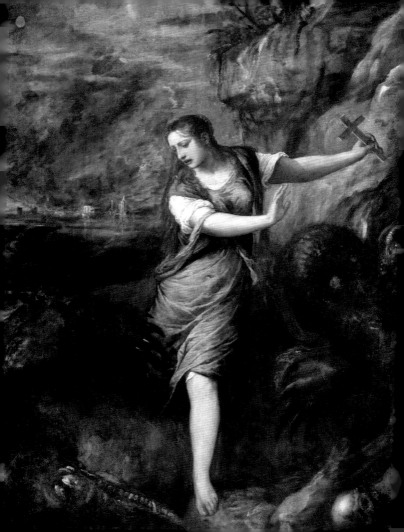

Lives of Titian

Giorgio Vasari

Francesco Priscianese

Pietro Aretino

Sperone Speroni

Ludovico Dolce

edited and introduced by
Carlo Corsato

translated by
Frank Dabell

The J. Paul Getty Museum, Los Angeles

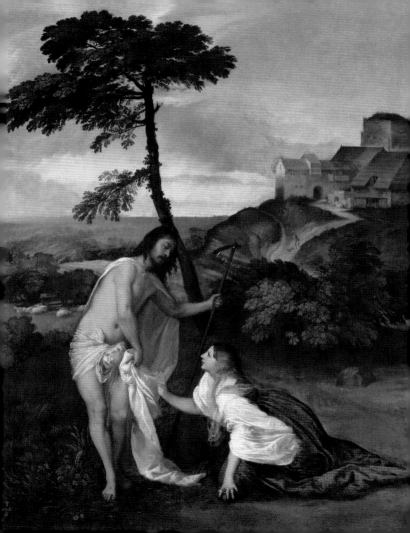

CONTENTS

Introduction by
CARLO CORSATO
p. 7

Life of Titian, 1568
GIORGIO VASARI
p. 29

Supper and conversation in Titian's house, 1540
FRANCESCO PRISCIANESE
p. 105

Letters about Titian, 1538, 1548 and 1550
PIETRO ARETINO
p. 113

Speaking of Titian, 1537
SPERONE SPERONI
p. 145

Titian, 1557
LUDOVICO DOLCE
p. 151

List of illustrations
p. 172

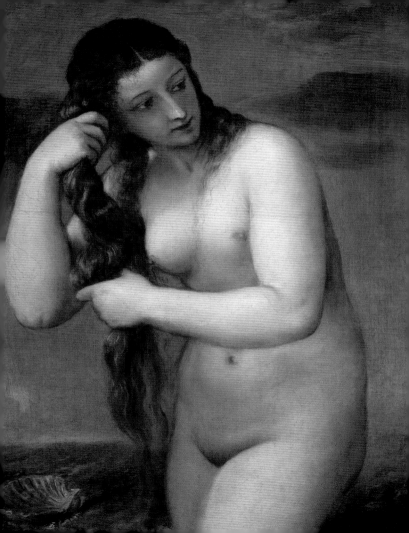

INTRODUCTION

CARLO CORSATO

In the spring of 1566, Giorgio Vasari paid a brief visit to Venice, seeking new information for his publishing project. Two years later the second, expanded version of his *Lives* came out (1568), finally including an independent biography of Tiziano Vecellio da Cadore. More than a few eyebrows had been raised when in the first edition (1550) only passing mention had been made of the greatest living painter of the *Serenissima Repubblica*. Indeed for over twenty years Titian had formed part of the Parnassus of the finest artists of his time, which included Andrea Mantegna, Giovanni Bellini, Leonardo, Michelangelo, and even the two Dossi brothers. In the 1532 edition of *Orlando furioso*, the poet Ludovico Ariosto had gone so far as to say that just as Venice and Urbino could claim to be proud of Sebastiano del Piombo and Raphael, respectively, so the valley of Cadore at the foot of the Alps could pride itself on its most famous son. In the years to come, with his own art, the boy from the

Opposite: Venus Anadyomene, c. 1520

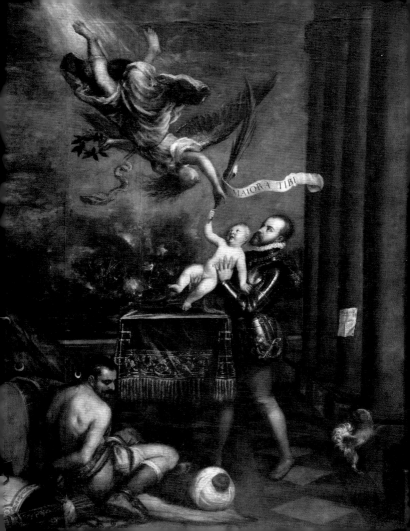

Dolomites would go on to conquer Venice, Italy and the courts of Europe, one after the other.

Ostensibly it seems inexplicable that the anti-Venetian prejudice of the 1550 edition of the *Lives* had also struck Titian, but in 1566, when he visited the artist's house and workshop, Vasari was fully intending to make up for that error. The drafting of the biography was at this point at a very advanced stage, and his brief encounter with the aged master was put to use for the finishing touches. Compiling the material had been in progress since December 1563, when Cosimo Bartoli, a Florentine diplomat in Venice, had assured Vasari that he was already engaged on it: 'As for the things on Titian, I shall also send you a note, which I have begun; but give me time'. Perhaps the painter himself was consulted, especially about paintings in Cadore and elsewhere beyond Venice, as well as commissions for Emperor Charles V, King Philip II of Spain, and other illustrious members of the Habsburg entourage. The same list was reused extensively by later authors believing (not entirely correctly) that it consisted mainly of first-hand information. In *Il Riposo* (1584), Raffaello Borghini summarized Vasari's text and corrected only a misprint in Titian's family name ('Vccelli' instead of the correct 'Vecelli').

Opposite: Philip II offering the Infante Fernando to Victory, 1573–75

In 1541-42, Vasari had already had occasion to make Titian's proper acquaintance when he visited Venice for a few months, at the invitation of the man of letters Pietro Aretino (who came, as his name indicates, from Vasari's own hometown of Arezzo). Aretino was one of the most influential socialites of his time, and his sharp-tongued invectives against those in power had earned him the epithet 'scourge of princes' *(flagello dei princi-pi)*. For the art of Titian, however (who was his close friend and frequent guest), Aretino was never sparing in his praise, above all in the sonnets, published in his *Letters*. In the *Dialogue on Love* (1542) by the Paduan humanist Sperone Speroni, the poet and courtesan Tullia d'Aragona had asserted that the poetry of the one was indissoluble from the portraits of the other: the sonnet lent voice to the canvas, and the painting clothed the verse in flesh and blood. In the *Lives*, however, Vasari transcribed only the opening of the sonnet on the *Portrait of Francesco Maria della Rovere* (Florence, Uffizi; see p. 119), attached to a letter of 1537 from Aretino to Veronica Gambara, but not even a short description was given of what he thought was 'a marvellous work'.

Vasari was more fulsome about the paintings he had admired in Venice, including the three masterworks

Opposite: Pietro Aretino, c. 1537

which had revolutionised the art of the altarpiece: the *Assumption of the Virgin* and the *Pesaro Madonna* in the Franciscan church of the Frari (both still in situ, see p. 157 and 161), and the *Death of St Peter Martyr* in the Dominican church of Santi Giovanni e Paolo (where it was destroyed by fire in 1867, see p. 114). He must then have been too busy to give them due attention, and he certainly failed to remember them clearly. A certain sloppiness, in fact, marked Vasari's description of the *Death of St Peter Martyr*: he based it mainly on the engraving by Martino Rota (c. 1560) and neglected Aretino's observations, included in his letter of 1537 to the sculptor Tribolo (see p. 115). As for the *Assumption,* Vasari stated that it was painted on canvas rather than wood panel, and lamented that it was poorly lit and badly looked after. After visiting Venice in 1582-83, the painter Annibale Carracci was so incensed by Vasari's errors and misconceptions that he felt obliged to protest. A copy of the *Lives* (Bologna, Library of the Archiginnasio), among the annotations of six other unidentified authors, still preserves Carracci's own remarks, some of them crude invective. In particular, commenting on the *Assumption*, Carracci explained that, although raking light might cast shadows over the picture during most of the day, there were particular times when its crisp colours could in fact be appreciated. It sounds as if Vasari did not bother to plan his visit properly.

If the details of the *Lives* need to be considered with care, its overall reconstruction of Titian's career was nonetheless quite accurate, if excessively dramatized here and there. In Vasari's account, for instance, after first appropriating the style of Giorgione, the young Titian then benefits from the death of Bellini (1516) to obtain his profitable *sanseria* (a lifelong broker's license) with its annual emolument of 300 *scudi* and succeed him in the role of official painter of the Republic of Venice (1523). In reality, this license was worth less than half as much, and gave the painter no formal appointment; yet it sufficed for Titian to be accepted as the old master's heir, obtain the job of portraying newly elected doges for the next thirty years, and complete Bellini's grand canvas in the Doge's Palace (lost in a fire in 1577).

Titian's exceptionally new manner drew the attention of many patrons, both in Venice and beyond. In his *General Principles of Architecture* (1551 edition), Sebastiano Serlio set a list of famous names in stone:

> if the great Titian, exemplar, father and master of painting in our time, had not first been highly rewarded – by Alfonso d'Este, Duke of Ferrara, who with great gifts knighted him; by the most generous Federico [Gonzaga] of Mantua, for whom he has made, and continues to make, many works; by

many other Lords and Cardinals, and above all
Charles V, Emperor, portrayed by him, who has
recognized his exalted virtue with great and hon-
ourable gifts and a new decoration of knighthood;
and finally by Your Excellency [Alfonso d'Avalos,
Marquis of Vasto], who has so kindly placed him
under his protection – I cannot believe that he
would ever have reached such heights in his works,
as can be seen in him.

Serlio drafted the list before 1540, when Federico
Gonzaga died, and it was followed by later biographers,
who inserted all these prestigious patrons in their ac-
counts on Titian and were more precise about some of
the many commissions from eminent prelates. Vasari, for
instance, mentioned the opening of Cardinal Giovanni
della Casa's sonnet on the portrait of the noblewoman
Elisabetta Querini (lost). Only brief mention, however,
was made by him of the *The Allocution of the Marquis del
Vasto to his Troops* (Madrid, Prado; see p. 124) and, once
again, Aretino's description in a letter of 1540 to d'Avalos
himself was ignored. It seemed Vasari wished to detract
from the role of such an illustrious patron, under the
ægis of whom Titian painted at least two other mas-
terpieces: the *Portrait of Alfonso d'Avalos* (Los Angeles,

Opposite: Portrait of a woman ('La Schiavona'), c. 1510-12

J. Paul Getty Museum, see p. 63) and the *Crowning with Thorns* for the church of Santa Maria delle Grazie in Milan (Paris, Louvre).

It was the courts of Ferrara and Mantua, however, that launched the painter onto the international stage. Alfonso d'Este, Duke of Ferrara, had asked Titian to modify the landscape in Bellini's *Feast of the Gods* (Washington, DC, National Gallery of Art), so as to better attune the picture to the other mythologies created by him for the *camerino d'alabastro* (the Alabaster Study): the *Worship of Venus*, the *Bacchanal of the Andrians* (both Madrid, Prado), and *Bacchus and Ariadne* (London, National Gallery) – the last of these left unmentioned by Vasari. An even more crucial relationship was generated by the long-lasting patronage of Federico Gonzaga, Duke of Mantua and nephew of Alfonso d'Este: apart from creating a superb likeness of him (Madrid, Prado, see p. 64), Titian painted numerous religious and mythological subjects, as well as the cycle of the *Eleven Cæsars* (lost), which acquired a fame as legendary as that of the *Triumphs of Cæsar* by Andrea Mantegna commissioned by the Gonzaga over fifty years previously (Hampton Court, Royal Collections). Above all, it was with the help of Gonzaga that the painter entered the good graces of Charles V, who, as Giovan Paolo Lomazzo recalled in the *Idea of the Temple*

of Painting (1590), 'loved and revered [Titian] as much as Alexander [the Great] had cherished Apelles'. Indeed, the Emperor sought to obtain the artist's move to his court (1533-35), but in the end Ambassador Lope de Soria had to admit defeat:

> I doubt he will go there [the Imperial Court], as I see him so much enamoured of and devoted to this, his Venice, which is starting to tire me, because it is certainly a kind prison for the likes of us little rascals.

Fifteen years later, though, Titian was persuaded to temporarily leave Venice, cross the Alps and meet Charles at the Diet of Augsburg (1548). Once again, Aretino did not fail to celebrate the visit of this Apelles to the court of his Alexander the Great. On that occasion Titian crafted another of his miracles, painting *The Emperor Charles V at Mühlberg* (Madrid, Prado; see p. 81), which over the next two centuries became the equestrian portrait par excellence for the rulers of Europe. We should not be surprised, then, that Prince Philip, the Emperor's son, had set his eyes on Titian well before becoming King of Spain. This was not love at first sight, as he did not initially appreciate the painter's swift and bold brushwork; in 1551, he confided to his aunt Mary

Overleaf: Bacchus and Ariadne, 1520-23

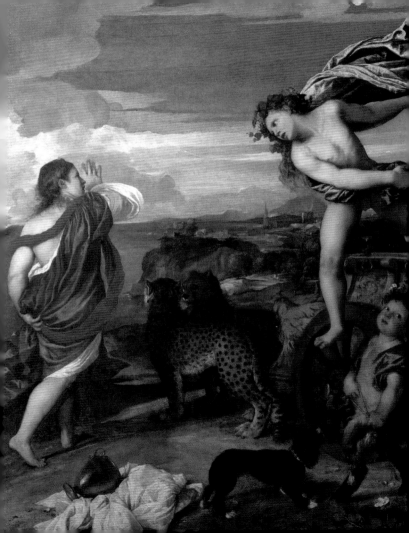

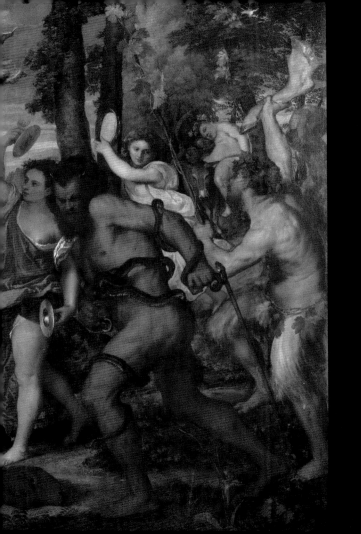

of Hungary that 'in my portrait in armour the haste with which he did it could clearly be perceived, and if there were more time I would make him re-do it'.

This did not stop Philip II from becoming Titian's most generous and loyal protector in the subsequent twenty-five years. Yet the Habsburgs were not the only great men in his glorious career. In 1545-46, the painter spent about eight months in Rome as guest of Pope Paul III and the cardinal-nephew Alessandro Farnese. Vasari had enjoyed the same protection, and had the privilege of guiding Titian around the sites of classical antiquity and showed him the finest modern works and monuments. Shortly after his arrival, Cardinal Pietro Bembo, the great man of letters and friend and protector of Titian, had immediately written to the Venetian patrician Girolamo Querini:

> Your (as well as our) Messer Titian is here, and he tells me that he is under great obligation to you for having been the cause of his coming to Rome, and passionately inciting him with the kindest words to make the trip [...]. He has already seen so many fine antiques that he is filled with wonder, and delighted that he came.

Vasari was somewhat less enthused when it came to noting Titian's evolution, and maliciously quoted a

remark by Sebastiano del Piombo on the first state of the woodcut of the *Triumph of Faith* (1508):

> if Titian had been in Rome at that time, and had seen the works of Michelangelo, those of Raphael, and the ancient statues, and had studied drawing, he would have done absolutely stupendous things, considering the beautiful mastery that he had in colouring.

After he had met the painter in Rome, while he was working on the *Danaë* for Cardinal Farnese (Naples, Museo Nazionale di Capodimonte), Michelangelo essentially confirmed the same judgment to Vasari: the art of colouring (*colorito*) was undoubtedly Titian's strong point, but he would never have excelled in drawing and design (*disegno*). It is not surprising that Carracci annotated this passage with bitter disappointment. Not only did Michelangelo not appreciate Titian's style, so different from his own, but above all it was offensive that Vasari had presented himself as the guide who had introduced Titian to the arts and antiques of Rome. If such impudence cost Vasari a scurrilous insult from Carracci, we may never know, on the other hand, whether Michelangelo really did express such a stern opinion. It is certain, however, that Vasari used the great artist's authority to respond to a passage in the *Dialogue on*

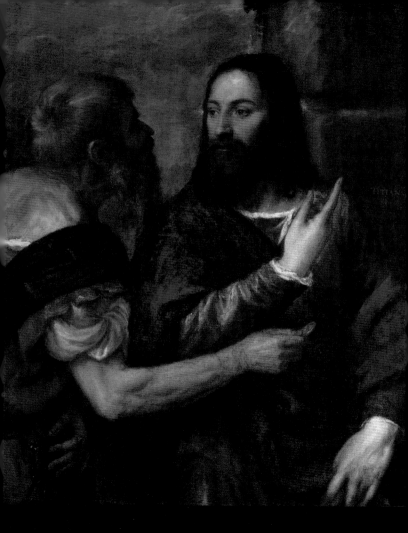

Painting, in which the Venetian theorist and friend of Titian, Ludovico Dolce, had entrusted to an imaginary Pietro Aretino – the real one had died in 1556, a year before its publication – the narration of the first biography of Titian ever written. According to Dolce/Aretino, the *Assumption* in the Frari, painted about thirty years before his journey to Rome, showed Titian's ability to leave behind him the masters of the preceding generation (Gentile and Giovanni Bellini), and – inspired by the sole example of Giorgione – successfully combine 'the grandeur and awe-inspiring quality' of Michelangelo, 'the pleasing grace and perfect beauty' of Raphael, and 'the proper colouring of Nature'. Hardly surprisingly, Vasari did not want to let Dolce get away with it.

However, if we read Dolce/Aretino carefully, Titian was not touched by these polemics: he disliked criticizing other artists, and in fact was a very modest man, notwithstanding the fact that even Apelles, the greatest painter of antiquity, would not have been averse to praising him. What is sure is that Aretino in his *Letters*, and then later Dolce in his *Dialogue*, gave ample shape to the overly sweet public image of Titian.

Named Count Palatine and Knight of the Golden Spur by the Emperor in 1533, Titian exuded the qualities

Opposite: The Tribute Money, 1560-68

of a refined gentleman with aristocratic manners: a person of fine speech, affable character and magnetic charisma. He respected religion but was not a conformist. Corrado della Marca, a Conventual Franciscan friar who was confessor of both Titian and Aretino, had been arrested for encouraging ideas that were not entirely orthodox, so much so that painter and writer had used their influence to try to release him from the galleys in 1549. Less turbulent but equally stimulating were the banquets held in the artist's home, like the one in 1540 attended by the humanist Francesco Priscianese: the dinner guests in Titian's garden that *ferragosto* evening included Aretino (a regular on such occasions), the writer Jacopo Nardi and the sculptor and architect Jacopo Sansovino. A menu of delicacies and fine wines, a tour of the host's works, and a discussion of Tuscan language over dessert all reminded Priscianese of those private gardens in Rome, the meeting-places of *literati* and cardinals.

An intellectual artist, Titian was not one to shrink from joining in the artistic debate of the age – the *paragone*, determining the primacy of sculpture or painting. Aretino asked Sansovino to make an effigy from the death mask of Giovanni delle Bande Nere, while Titian would have resurrected the late protector of the writer through one of his miraculous portraits. Not for nothing did Titian's personal device, published in 1562

by Battista Pittoni, have as its motto *Natura potentior ars* – 'Art [is] more powerful than Nature'. This was the equivalent of saying that a great and divine painter could exceed the limits of Nature. Little did it matter that in reality the portrait of Giovanni delle Bande Nere was executed by another painter, which enraged Aretino. What counted was that Titian was not an artisan of painting, but a poet of images. The implicit reference here was to the celebrated quotation from Horace: *ut pictura poesis*, or 'as with painting so with poetry'. Titian's late style spoke directly, and unaffectedly, with concealed brilliance, like the effortless nonchalance in manners and speech (*sprezzatura*) recommended by Baldassarre Castiglione in *The Courtier*. Vasari first realised one must look at Titian's poetic paintings from a distance, as a close inspection would show no fine detail, just the energy and vibrancy of the master's brushwork. Titian himself demonstrated this in his *poesie*, or visual poems, for Philip II, a mythological cycle inspired by Ovid's *Metamorphoses* which included *Venus and Adonis* (Madrid, Prado), *Diana and Callisto*, *Diana and Actæon* (London, National Gallery, and National Galleries of Scotland), and *The Rape of Europa* (Boston, Isabella Stewart Gardner Museum).

A member of the jet set, like many another gentleman of his time this new Apelles enjoyed life's pleasures and

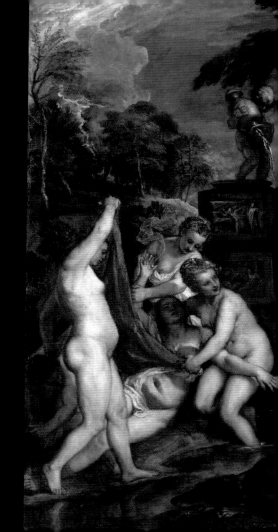

Diana and Callisto,
1556-59

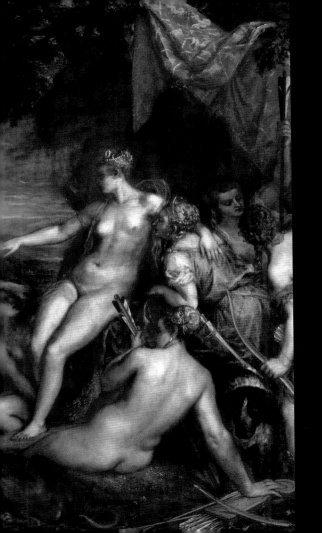

shared his table with courtesans: in 1547, Aretino invited him to tuck into a brace of pheasants and enjoy the company of the celebrated Angela Zaffetta. In the same year, a certain Lucrezia (another lady of easy virtue) had attended the wedding of Orazio, Titian's second son, who was also an artist. As in every family of stature, Titian's was not without its black sheep: notwithstanding Aretino's protection and the finest education, his first son Pomponio never found a true vocation, either in art or with the Church (the latter hoped for by his father), but by the irony of fate he remained the sole heir of the great artist. In 1576, the plague carried off Orazio, only weeks after the death of his father; but the memory of Titian survived in his works, together with the illusion that his art was really more powerful than Nature and Time.

TIZIANO DA CADOR
PITTORE.

*The Life of Tiziano Vecellio
Painter*

GIORGIO VASARI

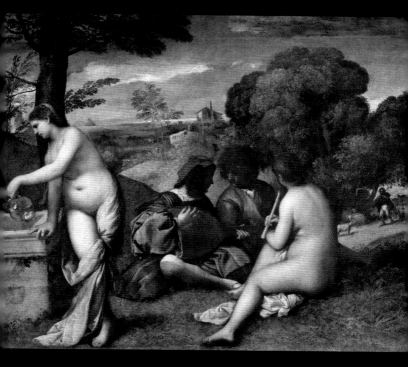

The Pastoral Concert, c. 1511

Titian* was born at Cadore, a little township situated on the [river] Piave and five miles distant from the pass of the Alps, in the year 1480, from the family of the Vecelli, one of the most noble in that place. At the age of ten, having a fine spirit and a lively intelligence, he was sent to Venice to the house of an uncle, an honoured citizen, who, perceiving the boy to be much inclined to painting, placed him with Giovanni Bellini, an excellent painter very famous at that time,† as has been related.

Under his discipline, attending to [the art of] drawing (*disegno*), he soon showed that he was endowed by nature with all the gifts of intellect and judgment that are necessary for the art of painting; and since at that time Giovanni Bellini and the other painters of that country, from not being able to study ancient works, were much – nay, altogether – given to copying from the life whatever work they did, and that with a dry,

Marginal note by Annibale Carracci: This most divine painter has made things that appear more the work of Angels of Heaven than by the hand of a mortal man, and in certain pieces, especially in portraits from life, he has surpassed all the painters in the world, by far. And this animal Vasari describes him almost as if he were any old painter.

† AC: At that time and still in our own time.

crude, and laboured manner, Titian also for a time learned that method.*

But having come to about the year 1507, Giorgione da Castelfranco, not altogether liking that method of working, began to give to his pictures more softness and greater relief, with a beautiful manner; nevertheless he used to set himself before living and natural objects and counterfeit them as well as he was able with colours, and paint them broadly with tints crude and soft following the living model, without doing any drawing, holding it as certain that to paint with colours only, without the study of drawing on paper, was the true and best method of working, and the true [art of] design (*disegno*). But he did not perceive that for one who wishes to dispose his compositions and accommodate his inventions well, it is necessary that he should first put them down on paper in several different ways, in order to see how the whole goes together, because the Idea is not able to see or imagine the inventions perfectly within herself, if she does not reveal and demonstrate her conception to the eyes

*AC: The ignorant Vasari does not realise that the great old masters derived their things from life, and he would rather have good depiction [coming] from secondary things, which are antique [sculptures], [themselves derived] from what is first and most primary: living things, which must always be imitated. But he did not understand this art [of painting].

of the body, that these may assist her to form a good judgment. Besides which, it is necessary to give much study to the nude, if you wish to comprehend it well, which you will never do, nor is it possible, without having recourse to paper; and to keep always before you, while you paint, persons naked or draped, is no small constraint, whereas, when you have trained your hand by drawing on paper, you then come little by little with greater ease to carry your conceptions into execution, drawing and painting together. And so, gaining practice in art, you make both manner and judgment perfect, doing away with the labour and effort with which those pictures were executed as we discussed above, not to mention that by drawing on paper, you come to fill the mind with beautiful conceptions, and learn to counterfeit all the objects of nature by memory, without having to keep them always before you or being obliged to conceal, beneath the glamour of colouring, the painful fruits of your ignorance of drawing, in the manner that was followed for many years by the Venetian painters, Giorgione, Palma [Vecchio], Pordenone, and others, who never saw Rome or any other works of absolute perfection.*

*AC: Almost as if one could not arrange [a composition] in a picture in different ways, cancelling and reworking it, as on paper; but I don't have the space to prove the bullshit of this incompetent Vasari.

Titian, then, having seen the method and manner of Giorgione, abandoned the manner of Giovanni Bellini, although he had been accustomed to it for a long time, and attached himself to that [of Giorgione]; coming in a short time to imitate his works so well, that his pictures at times were mistaken for works by Giorgione, as will be related below. Then, having grown in age, practice, and judgment, Titian executed many works in fresco, which cannot be enumerated in order, being dispersed over various places; let it suffice that they were such, that the opinion was formed by many experienced judges that he would become, as he afterwards did, a most excellent painter.

At the time when he first began to follow the manner of Giorgione, not being more than eighteen years of age, he made the portrait of a gentleman of the Barbarigo family, his friend, which was held to be very beautiful, the likeness of the flesh colouring being true and natural, and all the hairs so well distinguished one from another, that they might have been counted, as also might have been the stitches in a doublet of silvered satin that he painted in that work.[1] In short, it was held to be so well done, and with such

1. c. 1509, London, National Gallery

Opposite: Portrait of a Man with a Quilted Sleeve, c. 1509

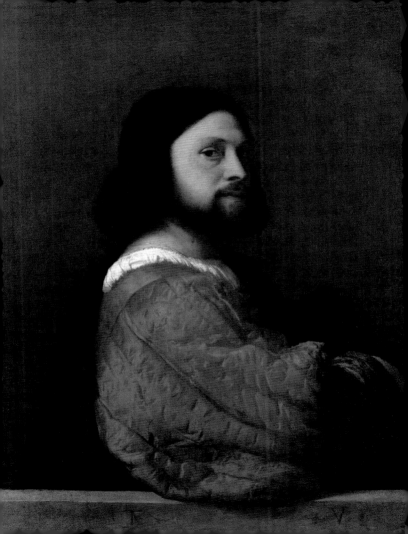

diligence, that if Titian had not written his name in *ombra*, it would have been taken for the work of Giorgione. Meanwhile Giorgione himself had executed the principal façade of the Fondaco dei Tedeschi, and by means of Barbarigo there were allotted to Titian certain scenes in the same [upper area on the façade] over the Mercerie.[1]

After which work he painted a large picture with figures of the size of life, which is now in the hall of Messer Andrea Loredan, who dwells in San Marcuola. In that picture is painted Our Lady going into Egypt, in the midst of a great forest and certain landscapes that are very well done,[2] because Titian had given his attention for many months to such things, and had kept in his house for that purpose some Germans who were excellent painters of landscapes and verdure. In the wood in that picture, likewise, he painted many animals, which he portrayed from the life; and they are truly natural, and almost alive. Next, in the house of Messer Giovanni d'Anna, a Flemish gentleman and merchant, his good friend, he made his portrait, which has all the appearance of life, and a picture with an Ecce Homo with many figures,

1. c.1508-9; Venice, Ca' d'Oro (fragments) 2. c.1508; probably the painting in St Petersburg, Hermitage

which is held by Titian himself and by others to be a very beautiful work.[1] For the same patron he painted a picture of Our Lady with other figures the size of life, of men and children, all portrayed from the life and from persons of that house.

Then in the year 1507, while the Emperor Maximilian was making war on the Venetians, Titian, according to his own account, painted an angel Raphael with Tobias and a dog in the church of San Marziale,[2] with a distant landscape, where, in a little wood, St John the Baptist is praying on his knees to Heaven, whence comes a radiance that illumines him; and this work it is thought that he executed before he made a beginning with the façade of the Fondaco dei Tedeschi. Concerning which façade, many gentlemen, not knowing that Giorgione was not working there any more or that Titian was doing it, who had uncovered one part, bumping into Giorgione, congratulated him in friendly fashion, saying that he was acquitting himself better in the façade towards the Mercerie than he had done in that which is over the Grand Canal. At which circumstance Giorgione felt such disdain, that until Titian had completely finished the work and it

1. In fact 1543. Vienna, Kunsthistorisches Museum 2. c. 1540-50, with workshop assistance; Venice, Madonna dell'Orto. Vasari mistook it for the earlier version in Santa Caterina

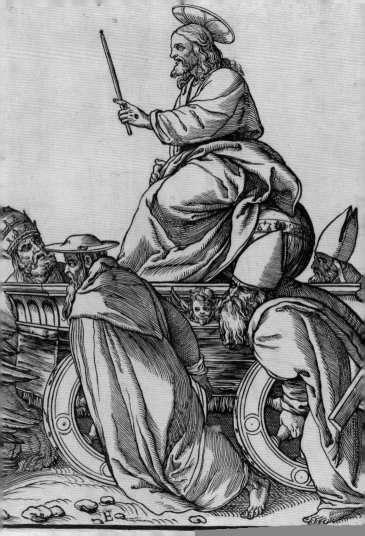

had become well known that the same had done that part, he would scarcely let himself be seen; and from that time onward he would never allow Titian to associate with him or be his friend.

In the following year, 1508, Titian published a wood-engraving of the *Triumph of Faith*, with an infinity of figures: our first Parents, the Patriarchs, the Prophets, the Sibyls, the Innocents, the Martyrs, the Apostles, and Jesus Christ borne in Triumph by the four Evangelists and the four Doctors [of the church], with the Holy Confessors behind.[1] In that work Titian displayed boldness, a beautiful manner, and the power to work with facility of hand; and I remember that Fra Sebastiano del Piombo, conversing of this, said to me that if Titian had been in Rome at that time, and had seen the works of Michelangelo, those of Raphael, and the ancient statues, and had studied the art of drawing, he would have done absolutely stupendous things, considering the beautiful mastery that he had in colouring, and that he deserved to be celebrated as the finest and greatest imitator of Nature in the matter of colour in our times, and if he had

1. Lost, but known through the 1543 edition published by Joos Lambrecht in Ghent

Opposite: Andrea Adreani (after Titian), Triumph of Faith (detail), 17th century

had the foundation of the best drawing he would have equalled Raphael and [Michelangelo] Buonarroti.

Afterwards, having gone to Vicenza, Titian painted the Judgment of Solomon in fresco, which was a beautiful work, under the little loggia where justice is administered in public audience.[1] He then returned to Venice, and painted the façade of the Grimani Palace. At Padua, in the church of Sant'Antonio, he executed likewise in fresco some stories of the actions of that saint,[2] and for that of Santo Spirito he painted a little altarpiece with a St Mark seated in the midst of certain saints, in whose faces are some portraits from life done in oils with the greatest diligence; which picture many have believed to be by the hand of Giorgione.[3] Then, a scene having been left unfinished in the Hall of the Great Council through the death of Giovanni Bellini, in which Frederick Barbarossa is kneeling at the door of the church of San Marco before Pope Alexander the Fourth, who places his foot on Barbarossa's neck, Titian finished it, changing many things, and making there many portraits from life of

1. Destroyed in c. 1549 2. Three frescoes: *The Miracle of the Speaking Babe*; *The Miracle of the Irascible Son*; *The Miracle of the Jealous Husband*, 1511, Padua, Confraternity of St Anthony (Scoletta del Santo) 3. *St Mark Enthroned with Sts Cosmas and Damian, Roch and Sebastian*, c. 1508-9, Venice, Santa Maria della Salute

The Miracle of the Speaking Babe, 1511

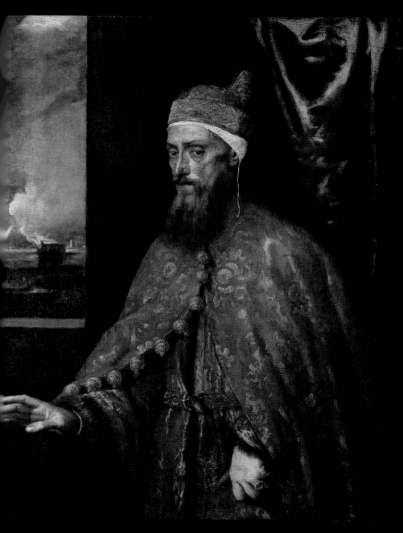

his friends and others;[1] for which he was rewarded by receiving from the Senate an office in the Fondaco dei Tedeschi, called the Senseria, which yields three hundred scudi a year. That office those Signori are accustomed to give to the most excellent painter of their city, on the condition that he shall be obliged from time to time to paint the portrait of their prince, or doge, at his election, for the price of only eight scudi, which the prince himself pays to him; which portrait is afterwards kept, in memory of him, in a public place in the Palace of S. Marco.

In the year 1514 Duke Alfonso of Ferrara had caused a little chamber [*camerino*] to be decorated, and had commissioned the Ferrarese painter Dosso [Dossi] to execute in certain compartments stories of Æneas, Mars, and Venus, and in a grotto Vulcan with two smiths at the forge; and he desired that there should also be there pictures by the hand of Giovanni Bellini. Bellini painted on another wall a vat of red wine with some bacchantes around it, and satyrs, musicians, and other men and women, all drunk with wine, and near them a nude and very beautiful Silenus, riding on his

1. *Emperor Frederick Barbarossa kneeling before Pope Alexander III* [sic] *outside Saint Mark, 1507-16*; completed by Titian in 1523, lost in a fire (1577)

Opposite: Doge Francesco Venier, 1554-56

ass, with figures about him that have their hands full of fruits and grapes; which work was in truth executed and coloured with great diligence, insomuch that it is one of the most beautiful pictures that Giovanni Bellini ever painted, although in the manner of the draperies there is a certain sharpness after the German manner.[1] (This is not so surprising because he imitated a picture by the Northerner Albrecht Dürer, which had been brought in those days to Venice and placed in the church of San Bartolomeo, a rare work and full of most beautiful figures painted in oils.[2]) On that vat Giovanni Bellini wrote these words: JOANNES BELLINUS VENETUS/P. 1514. That work he was not able to finish completely, because he was old, and Titian, as the most excellent of all the others, was sent for to the end that he might finish it; wherefore, being desirous to acquire [reputation] and to make himself known, he executed with much diligence two scenes that were wanting in that little chamber.*

In the first is a river of red wine, about which are

*AC: These paintings can indeed be praised as the most beautiful in the world, and whoever has not seen them can say that they have never seen any marvel of art.

1. 1514; *Feast of the Gods*, with background altered by Titian in 1529. Washington, DC, National Gallery of Art 2. *Feast of the the Rose Garlands*, 1506, Prague, National Gallery

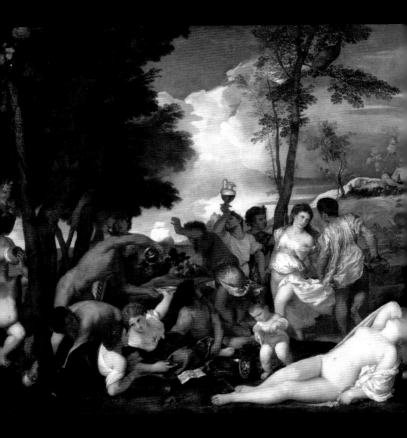

The Bacchanal of the Andrians, c. 1519-21

singers and musicians, both men and women, as it were drunk, and a naked woman who is sleeping, so beautiful that she might be alive, together with other figures; and on this picture Titian wrote his name.[1] In the other, which is next to it and seen first on entering, he painted many little cupids and beautiful putti in various attitudes,[2] which much pleased that lord, as also did the other picture; but most beautiful of all is one of those putti who is urinating into a river and is reflected in the water,[3] while the others are around a pedestal that has the form of an altar, upon which is a statue of Venus with a sea-conch in the right hand, and Grace and Beauty about her, which are very lovely figures and executed with incredible diligence. On the door of a cabinet, likewise, Titian painted a portrait Christ from the waist upwards, marvellous and stupendous, to whom a simple Hebrew is showing the coin of Cæsar; which image, and also other pictures in that little chamber, our best craftsmen declare to be the finest and best executed that Titian has ever done, and indeed they are most rare.[4] Wherefore he well deserved to be most liberally recompensed and

1. *The Bacchanal of the Andrians*, c. 1519-21. Madrid, Prado 2. *The Worship of Venus*, 1518-19. Madrid, Prado 3. The detail is actually depicted in *The Bacchanal of the Andrians* 4. c. 1516. Dresden, Staatliche Gemäldegalerie

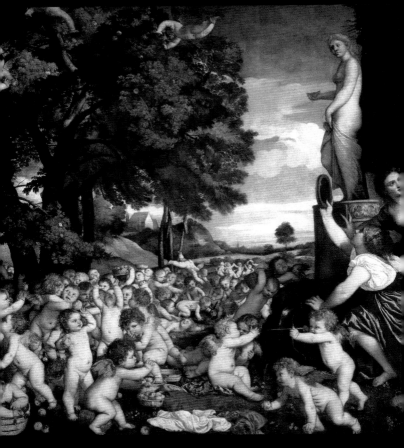

The Worship of Venus, 1518-19

rewarded by that lord, whom he portrayed excellently well with one arm resting on a great piece of artillery;[1] and he also made a portrait of Signora Laura, who afterwards became the wife of the Duke, which is a stupendous work.[2]

And, in truth, gifts have great potency with those who labour for the love of art, when they are uplifted by the liberality of princes. At that time Titian formed a friendship with the divine Messer Ludovico Ariosto, and was recognized by him as a most excellent painter and celebrated in his *Orlando Furioso*:

> Sebastiano [del Piombo], Raphael, and Titian,
> > who brings honour to Cadore
> No less than those two have to Venice and Urbino.

Having then returned to Venice, Titian painted on a canvas in oils, for the father-in-law of Giovanni da Castel Bolognese, a naked shepherd and a country girl who is offering him some pipes, that he may play them, with a most beautiful landscape; which picture is now at Faenza, in the house of the said Giovanni.[3] He

1. A copy in New York, Metropolitan Museum of Art 2. *Laura Eustochia* (called *Dianti*), c. 1529. Kreuzlingen, H. Kisters Collection 3. *Three Ages of Man*, c. 1513. Edinburgh, National Galleries of Scotland

then executed for the high altar in the church of the Friars Minor, called the Ca' Grande, a picture of Our Lady ascending into Heaven, and below her the twelve Apostles, who are gazing upon her as she ascends; but of this work, from its having been painted on canvas, and perhaps not well kept, there is little to be seen.[1]*

For the Chapel of the Pesaro family, in the same church, he painted in an altarpiece the Madonna with the Child in her arms, a St Peter and a St George, and about them the patrons of the work, kneeling and portrayed from life; among whom are the Bishop of Paphos and his brother, then just returned from the victory which that bishop won against the Turks.[2] For the little church of San Niccolò [della Lattuga], in the same convent, he painted in an altarpiece St Nicholas, St Francis, St Catherine, and also a nude St Sebastian, [truly] drawn from life and without any artifice whatever that can be seen to have been used to enhance the beauty of the legs and torso, there

*AC: *This work is not badly taken care of, and it is fresh and beautiful, but it cannot be viewed well because of two large windows that hinder the eyes; nonetheless at a certain time of day because of reflected light it can be seen to very good effect, enough to say that it is by the hand of the great Titian.*

1. *Assumption of the Virgin* (or *Assunta*), 1515-18, still in situ, see p.156
2. *Pesaro Madonna*, 1519-26, still in situ, see p.161

being nothing there but what one sees in the work of Nature, insomuch that it all appears as if taken from the life, so fleshlike it is and natural; but for all that it is held to be beautiful, as is also very lovely the Madonna with the Child in her arms at whom all those figures are gazing.[1] The subject of that picture was drawn on wood by Titian himself, and then engraved by others and printed. For the church of San Rocco, after the works described above, he painted a picture of Christ with the Cross on His shoulder, and about His neck a cord that is drawn by a Hebrew; and that figure, which many have believed to be by the hand of Giorgione, is now the object of the greatest devotion in Venice, and has received in alms more scudi than Titian and Giorgione ever gained in all their lives.[2]

Then he was invited to Rome by [Pietro] Bembo, whom he had already portrayed,[3] and who was at that time Secretary to Pope Leo X, to the end that he might see Rome, Raphael of Urbino, and others; but Titian delayed that visit so long from one day to

1. c. 1512-1514 (first version), c. 1521-22 (second version). Vatican City, Vatican Museums 2. c. 1508-9, Venice, Scuola Grande di San Rocco. Vasari also attributed it to Giorgione 3. Possibly 1513

Opposite: Madonna with Child and Saints, c. 1521-22

another, that Leo and Raphael died in 1520, and he ended up not going.*

For the church of Santa Maria Maggiore he painted a picture with St John the Baptist in the Desert among some rocks, an angel that appears as if alive, and a little piece of distant landscape with some trees upon the bank of a river, all full of grace.[1]†

He made portraits from life of the Prince [Antonio] Grimani and [Leonardo] Loredan, which were held to be admirable; and not long afterwards of King François, when he departed from Italy in order to return to France. And in the year when Andrea Gritti was elected Doge, Titian painted his portrait,[2] which was a very rare thing, in a picture wherein are Our Lady, St Mark, and St Andrew with the countenance of that Doge; which picture, a most marvellous work, is in the Council Hall.[3] And

*AC: Bembo was wrong to invite him to see those things, since as chance would have it he knew about even more beautiful ones, and for this reason he never wished to go. †AC: And what should be said when he says that what seems alive calls for even greater praise? In other passages he says instead that [Titian] lacked any skill in drawing. Oh, that incompetent Vasari!

1. c. 1531-32. Venice, Accademia 2. 1523, lost in a fire (1577). A replica in Scotland, private collection 3. 1531, lost in a fire (1574) but known through an anonymous woodcut

Opposite: St John the Baptist in the Desert, c. 1531-32

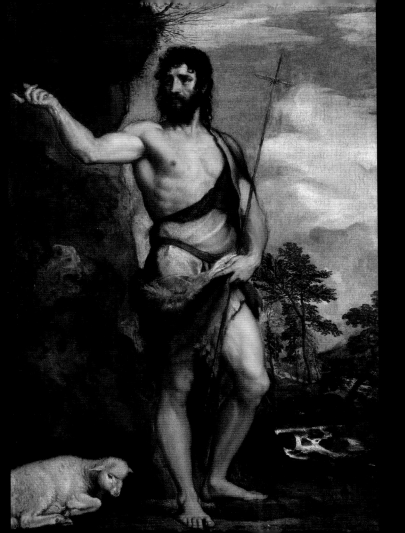

since, as I related, he was obliged to do so, he has also portrayed, in addition to those I named above, the others who have been doges in their time: Pietro Lando, Francesco Donà, Marcantonio Trevisan, and [Francesco] Venier. But by the two Doges and brothers [Lorenzo and Girolamo] Paoli [*sic*: Priuli] he has been excused recently, because of his great age, from that duty.

Before the Sack of Rome there had gone to live in Venice Pietro Aretino, a most famous poet of our times, and he became very much the friend of Titian and [Jacopo] Sansovino; which brought great honour and advantage to Titian, for the reason that the poet made him known wherever his pen reached, and especially to important princes, as will be told in the proper place. Meanwhile, to return to Titian's works, he painted the altarpiece for the altar of St Peter Martyr in the church of Santi Giovanni e Paolo, depicting therein that holy martyr larger than life, in a forest of very great trees, fallen to the ground and assailed by the fury of a soldier, who has wounded him so grievously in the head, that as he lies but half alive there is seen in his face the horror of death, while in another friar who runs forward

Opposite: Doge Andrea Gritti, 1546-50

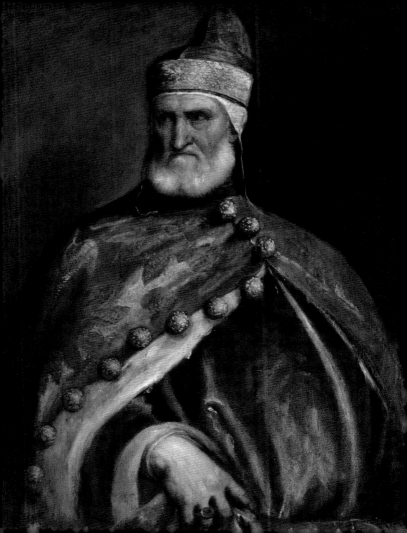

[the beholders] in flight may be perceived the fear and terror of death. In the air are two nude angels coming down from a flash of Heaven's lightning, which gives light to the landscape, which is most beautiful, and to the whole work besides, which is the best crafted, the most celebrated, the greatest, and the best conceived and executed that Titian has as yet ever done in all his life.[1] This work being seen by Gritti, who was always very much the friend of Titian, as also of Sansovino, he caused to be allotted to him a great scene of the rout of Ghiaradadda, in the Great Council Hall. In it he painted a battle with soldiers in furious combat, while a terrible rain falls from Heaven; which work, wholly taken from life, is held to be the best of all the scenes that are in that Hall, and the most beautiful.[2]*

*AC: This narrative, along with the others in that hall, and in many other chambers, burned down with a part of the palace, and those Lords assessed that painting as a greater loss than many others that were burned in such a noble part of their palace, and other things of the greatest value that perished; and even if they were later re-done by other painters, indeed as excellent as they may have been, they did not achieve the excellence of the great Titian, of Giorgione, of Giovanni Bellini, of Pordenone, and others.

1. 1525-30; lost in a fire, 1867. A copy by Niccolò Cassana (often attributed to Johann Carl Loth) replaced it 2. 1538, *Battle of Ghiaradadda* (or *Ghiara d'Adda*), lost in a fire, 1577. See also Dolce, p. 163

And in the same palace, at the foot of a staircase, he painted a Madonna in fresco.[1]

Having made not long afterwards for a gentleman of the Contarini family a picture of a very beautiful Christ, who is seated at table with Cleophas and Luke, it appeared to that gentleman that the work was worthy to be in a public place, as in truth it is.[2] Wherefore having made a present of it, like a true lover of his country and of the commonwealth, to the Signoria, it was kept a long time in the apartments of the Doge; but at the present day it is in a public place, where it may be seen by everyone, in the Gilded Chamber in front of the Hall of the Council of Ten, over the door.

About the same time, also, he painted for the Scuola of Santa Maria della Carità Our Lady ascending the steps of the Temple, with heads of every kind portrayed from nature;[3] and for the Scuola of San Fantino, likewise, a little altarpiece of St Jerome in Penitence,[4] which was much extolled by other artists, but was consumed by fire two years ago together with the whole church.

1. c. 1523. Formerly in the chapel of San Niccolò (destroyed) near the Giants' Staircase; currently in the Sala della Quarantia Criminal 2. c. 1535. Brocklesby Park, Lincolnshire 3. 1534-38; still in the former boardroom of the confraternity, now part of the Accademia galleries 4. Possibly known through an engraved copy by Cornelis Cort

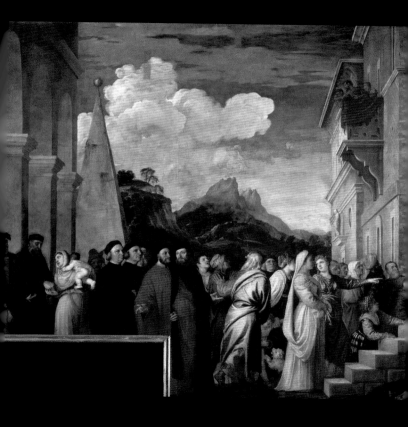

*Presentation of the Virgin
at the Temple,
1534-38*

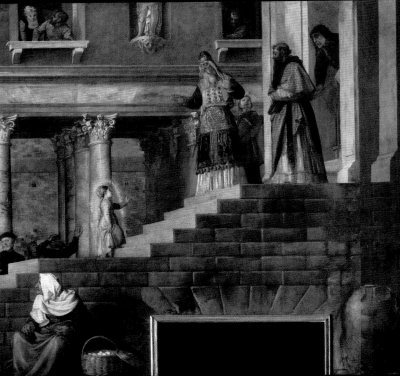

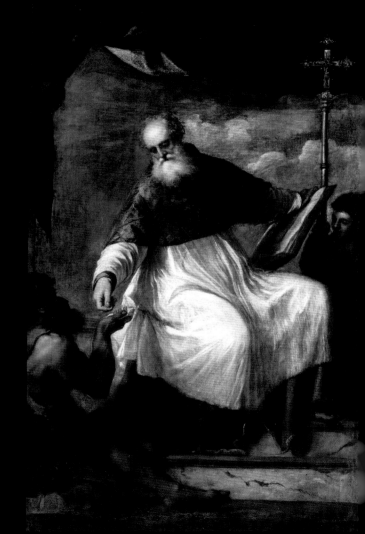

It is said that in the year 1530, the Emperor Charles V being in Bologna, Titian was invited to that city by Cardinal Ippolito de' Medici, through the agency of Pietro Aretino. There he made a most beautiful portrait of his Majesty in full armour, which so pleased him, that he caused a thousand scudi to be given to Titian; but of these he was obliged afterwards to give the half to the sculptor Alfonso Lombardi, who had made a model to be reproduced in marble, as was related in his *Life*. Having returned to Venice, Titian found that a number of gentlemen, who had taken Pordenone into their favour, praising much the works executed by him on the ceiling of the Senate Chamber and elsewhere, had caused a little altarpiece to be allotted to him in the church of San Giovanni Elemosinario,[1] to the end that he might paint it in competition with Titian, who for the same place had painted a short time before the said St John the Almoner in the habit of a bishop.[2] But, for all the diligence that Pordenone devoted to that altarpiece, he was not able to equal or even by a great measure to approach to the work of Titian. Next, [Titian] executed a most beautiful altarpiece of an Annunciation for the church of

1. *Sts Sebastian, Catherine and Roch*, c. 1535, in situ 2. c. 1550, still in situ

Opposite: Saint John the Almoner, c. 1550

Santa Maria degli Angeli at Murano, but he who had caused it to be painted not being willing to spend five hundred scudi upon it, which Titian was asking, by the advice of Messer Pietro Aretino he sent it as a gift to the said Emperor Charles V, who, liking that work vastly, made him a present of two thousand scudi;[1] and where that picture was to have been placed, there was set in its stead one by the hand of Pordenone.[*2]

Nor had any long time passed when Charles V, returning to Bologna to confer with Pope Clement [VII], at the time when he came with his army from Hungary, desired to be portrayed again by Titian. Before departing from Bologna, Titian also painted a portrait of the said Cardinal Ippolito de' Medici in Hungarian dress,[3] and in a smaller picture the same man in full armour; both which portraits are now in the guardaroba of Duke Cosimo [de' Medici]. At that same time he executed a portrait of Alfonso d'Avalos, Marquis of Vasto,[4] and one of the said Pietro Aretino,

*AC: For all Pordenone's excellence this work is nonetheless one of the minor things he did.

1. c.1536; destroyed (1807-14). Engraved copy by Jacopo Caraglio
2. c.1537, still in situ 3. c.1533, Florence, Pitti 4. 1533, Los Angeles, J. Paul Getty Museum

Opposite: Portrait of Alfonso d'Avalos, Marquis of Vasto, in Armour with a Page, 1533

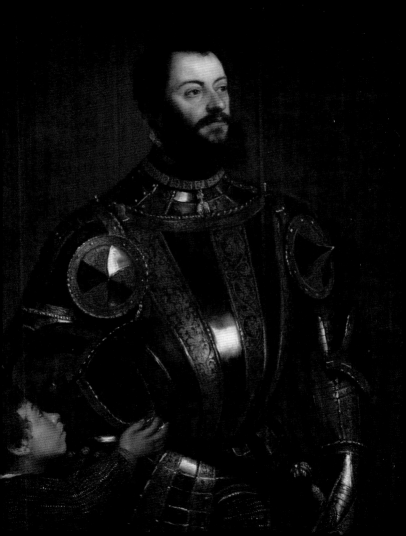

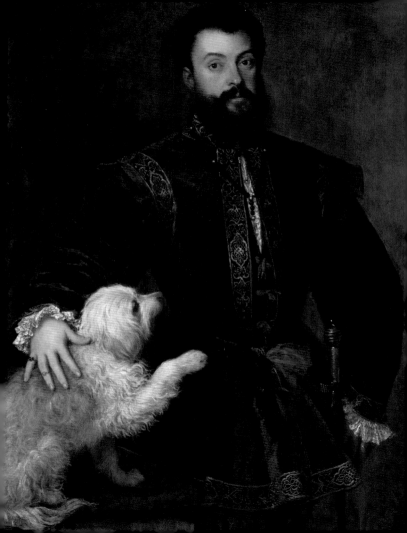

who then contrived that he should become the friend and servant of Federigo Gonzaga, Duke of Mantua, with whom Titian went to his own state and there painted a portrait of him, which is a living likeness,[1] and then one of the Cardinal, his brother. These finished, he painted, for the adornment of a room among those of Giulio Romano, twelve figures from the waist upwards of the twelve Cæsars, very beautiful, beneath each of which the said Giulio afterwards painted a story from their lives.[2]*

In Cadore, his birthplace, Titian has painted a picture in which are seen Our Lady, St Titian the Bishop, and a portrait of himself kneeling.[3] In the year when Pope Paul III went to Bologna, and from there to Ferrara, Titian, having gone to the Court, made a portrait of that Pope, which was a very beautiful work,[4] and from it another for [his nephew] Cardinal [Guido Ascanio Sforza di] Santa Fiora;[5] and both these portraits,

*AC: Very beautiful, to the extent that one can neither equal nor surpass them.

1. 1529-30, Madrid, Prado 2. *Eleven Cæsars*, 1536-39, lost in a fire (1734). Bernardino Campi added a twelfth Cæsar (Domitian, 1562) and copied the whole series (Naples, Museo di Capodimonte); engraved copies also by Ægidius Sadeler 3. c. 1565-66, Pieve di Cadore, Santa Maria Nascente 4. 1543, Naples, Museo di Capodimonte. See also Aretino's letter, p. 133 5. Unidentified, or lost

Opposite: Federico Gonzaga, 1st Duke of Mantua, 1529

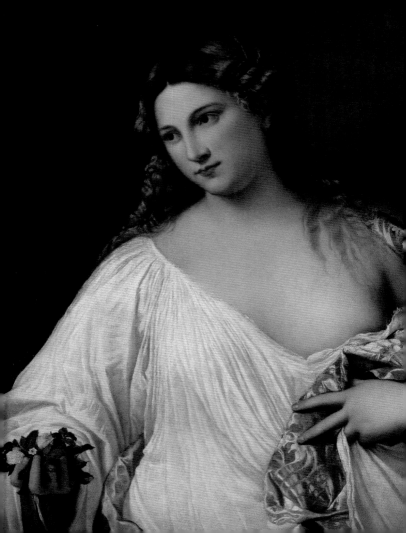

for which he was very well paid by the Pope, are in Rome, one in the *guardaroba* of Cardinal [Alessandro] Farnese, and the other in the possession of the heirs of the said Cardinal di Santa Fiora, and from them have been taken many copies, which are dispersed throughout Italy. About the same time, also, he made a portrait of Francesco Maria [della Rovere], Duke of Urbino, which was a marvellous work;[1] wherefore this prompted Messer Pietro Aretino to celebrate him in a sonnet that began:

> If the eminent Apelles with the hand of art
> A likeness gave of Alexander's face and breast.[2]

There are in the *guardaroba* of the same Duke, by the hand of Titian, two most lovely heads of women, and a young recumbent Venus with flowers and certain light draperies about her, very beautiful and well finished;[3] and, in addition, a figure of St Mary Magdalene with the hair all loose, which is a rare work.[4] There, likewise, are the portraits of Charles V, King François as a young man,[5] Duke Guidobaldo II, Pope

1. 1536, Florence, Uffizi, see p. 119 2. See Aretino's letter, pp. 117–21
3. The *Venus of Urbino*, c. 1533-38, Florence, Uffizi 4. c. 1535-37, Florence, Pitti 5. Possibly, Lausanne, De Coppet collection

Opposite: Flora, 1516-18

Overleaf: Venus of Urbino, c. 1533-38

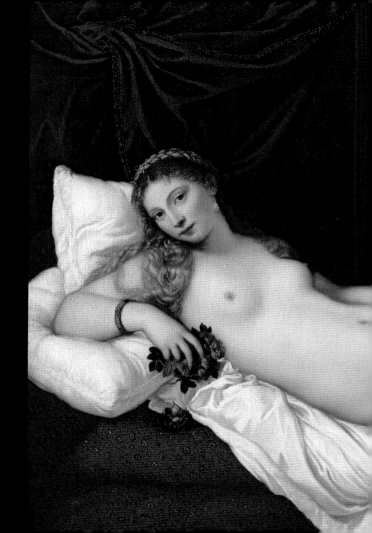

Sixtus IV,[1] Pope Julius II,[2] Paul III, the old Cardinal of Lorraine, and Suleiman Emperor of the Turks; which portraits, I say, are by the hand of Titian, and most beautiful. In the same *guardaroba*, besides many other things, is a portrait of Hannibal the Carthaginian, engraved in an antique cornelian, and also a very beautiful head in marble by the hand of Donatello.

In the year 1541 Titian painted for the friars of Santo Spirito in Isola, in Venice, the altarpiece of their high altar, figuring in it the Descent of the Holy Spirit upon the Apostles, with a God depicted as of fire, and the Holy Spirit as a dove; which altarpiece becoming spoiled in no long time, after having many disputes with those friars he had to paint it again, and it is that which is over the altar at the present day.[3] For the church of Santi Nazaro e Celso in Brescia he executed the altarpiece of the high altar in five pictures; in the centre [there] is Jesus Christ resurrected, with some soldiers around, and at the sides are St Nazarius, St Sebastian, the Angel Gabriel, and the Virgin receiving the Annunciation.[4] In a picture for the wall at the entrance of the Duomo of Verona, he painted

1. c. 1545-46, Florence, Uffizi 2. c. 1545-46, Florence, Pitti 3. c. 1546-47, with workshop assistance. Venice, Santa Maria della Salute 4. *Resurrection Polyptych*, in fact 1519-22, still in situ

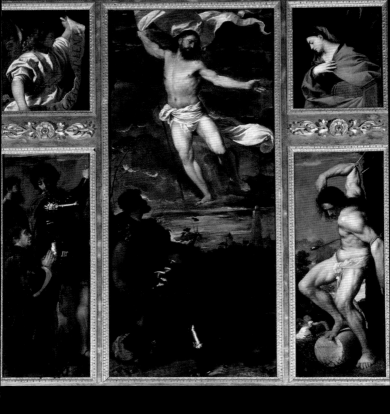

Resurrection Polyptych, 1519-22

an Assumption of Our Lady into heaven, with the Apostles on the ground [below], which is held to be the best of the modern works in that city.[1]

In the year 1541 he made the portrait of Don Diego Hurtado de Mendoza[2], at that time ambassador of Charles V in Venice, a whole-length figure and standing, which was very beautiful; and with this Titian began what has since come into fashion, namely the making of some portraits in full length. In the same manner he painted that of the cardinal of Trent [Cristoforo Madruzzo], then a young man,[3] and for Francesco Marcolini the portrait of Messer Pietro Aretino, though this was by no means as beautiful as another one, likewise by the hand of Titian, which Aretino himself sent as a present to Duke Cosimo de' Medici,[4] to whom he sent also the head of Signor Giovanni de' Medici [or, Giovanni delle Bande Nere], the father of the said lord duke.[5] That head was copied from a cast taken from the face of that lord when he died at Mantua, which was in the possession of Aretino;[6] and both these portraits are in the *guardaroba*

1. c. 1530-32, still in situ 2. 1541; possibly the *Portrait of a Man* (inv. 215), Florence, Pitti 3. Lost, or misdated by Vasari; a later version survives: 1552, São Paulo, Museu de Arte 4. 1545, Florence, Pitti 5. 1545, Florence, Uffizi; by Gian Paolo Pace 6. See Aretino's letter, p. 136

of the same lord duke, among many other most noble pictures.

The same year, Vasari, having been thirteen months in Venice to execute, as has been related, a ceiling for Messer Giovanni Corner, and some works for the Compagnia della Calza, Sansovino, who was directing the construction of Santo Spirito, had commissioned him to make designs for three large pictures in oils which were to go into the ceiling, to the end that he might execute them in painting; but, Vasari having afterwards departed, those three pictures were allotted to Titian, who executed them most beautifully, from his having contrived with great art to make the figures foreshortened from below upwards.*

In one is Abraham sacrificing Isaac, in another David severing the head of Goliath, and in the third Abel slain by his brother Cain. About the same time Titian painted a portrait of himself, in order to leave that memory of himself to his children.[1]

The year 1546 having come, he went at the invitation of Cardinal Farnese to Rome, where he found

*AC: *The presumptuous Vasari seems to want to say that if you don't have a horse you can use an ass, but he was the ass, because he was never asked to paint those three pictures.*

1. c.1545-47; possibly the painting in Berlin, Staatliche Museen, Gemäldegalerie

Vasari, who, having returned from Naples, was working for the said cardinal on the Sala dei Cento Giorni in the Palazzo della Cancelleria; whereupon, Titian having been recommended by that nobleman to Vasari, Giorgio kept him company lovingly in taking him about to see the sights of Rome.*

And then, after Titian had rested for some days, rooms were given to him in the Belvedere, to the end that he might set his hand to painting once more the portrait of Pope Paul, of full length, with one of [Cardinal Alessandro] Farnese and one of Duke Ottavio, which he executed excellently well and much to the satisfaction of those noblemen.[1] At their persuasion he painted, for presenting to the Pope, a picture of Christ from the waist upwards in the form of an Ecce Homo, which work, whether it was that the works of Michelangelo, Raphael, Polidoro [da Caravaggio],

*AC: How f***ing shameless Vasari is! He speaks so dishonourably that with that he's going to take me beyond any decorum. This oaf pretends to be the archimandrite [i.e. custodian] of painting, and he has the presumption to boast, almost, that he was the teacher of the greatest painters in the world. And then, it so happened that Titian didn't disdain to speak with him, as well as being entrusted to him.

1. 1545-46, Naples, Museo Nazionale di Capodimonte

Opposite: Ecce Homo, 1547

and others had made him lose heart, or for some other reason, did not appear to the painters, although it was a good picture, to be of the same excellence as many others by his hand, and particularly his portraits.*

Michelangelo and Vasari, going one day to visit Titian in the Belvedere, saw in a picture that he had executed at that time a nude woman representing Danaë, who had in her lap Jove transformed into a rain of gold; and they praised it much, as one does in the painter's presence.[1] After they had left him, discoursing of Titian's method, Buonarroti commended it highly, saying that his colouring and his manner much pleased him, but that it was a pity that in Venice [artists] did not learn to draw well from the beginning, and that those painters did not pursue a better method in their studies. "For," he said, "if this man had been at all assisted by art and design, as much as he is by Nature, and above all in counterfeiting the life, no one could do more or work better, for he has a fine spirit and a very beautiful and vivid manner." And in fact this is true, for the reason that he who

AC: I am sure that Titian did not lose heart because he saw the works of the painters of Rome, or for any other reason, but Vasari did not recognise how good Titian's painting was.

1. 1545-46, Naples, Museo Nazionale di Capodimonte

has not drawn much nor studied well-selected ancient and modern works, cannot work well from memory by himself or improve the things that he copies from life, giving them the grace and perfection that art provides [and] are beyond the reach of Nature, which normally produces some parts that are not beautiful.*

Titian, finally departing from Rome, with many gifts received from those noblemen, and in particular a benefice of good value for his son Pomponio, set himself on the road to return to Venice, after Orazio, his other son, had made a portrait of Messer Battista Ceciliano, an excellent player of violone, which was a very good work,¹ and he himself had painted some other portraits for Duke Guidobaldo of Urbino. Arriving in Florence, and seeing the rare works of that city, he was amazed by them no less than he had been by those of Rome. And besides that, he visited Duke Cosimo [de' Medici], who was at Poggio a Caiano, offering to paint his portrait; to which his Excellency did not give much heed, perhaps because [he did not

*AC: Things by Titian do not resemble those by Michelangelo and for this reason they did not entirely please him, but I know this: that they appear to be alive.

1. Possibly the painting in Rome, Galleria Spada

Overleaf: Danaë, 1545

77

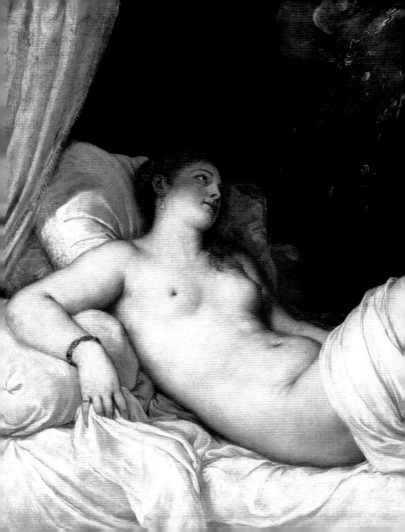

wish] to do a wrong to the many distinguished artists of his city and dominion.*

Then, having arrived in Venice, Titian finished for the Marquis of Vasto an Allocution (for so they called it) made by that nobleman to his soldiers;[1] and after that he executed the portraits of Charles V, that of the Catholic King [Philip II], and many others. These works had been finished, he painted a little altarpiece of the Annunciation for the church of Santa Maria Nuova in Venice; and then, with the help of his young assistants [*giovani*], he painted a Last Supper in the refectory of the convent of Santi Giovanni e Paolo,[2] and for the high altar of the church of San Salvador an altarpiece in which [there] is a Christ Transfigured on Mount Tabor, and for another altar in the same church a Madonna receiving the Annunciation from the Angel.[3] But these latter works, although there is something of the good to be seen in them, are not much esteemed by him, and have not the perfection that his other pictures have. And since the works of Titian are without number, and particularly the

*AC: *Vasari means himself. What an idiot.*

1. c. 1540-41, Madrid, Prado 2. Lost in a fire (1571) 3. c. 1565, both still in situ

Opposite: The Emperor Charles V at Mühlberg, 1548

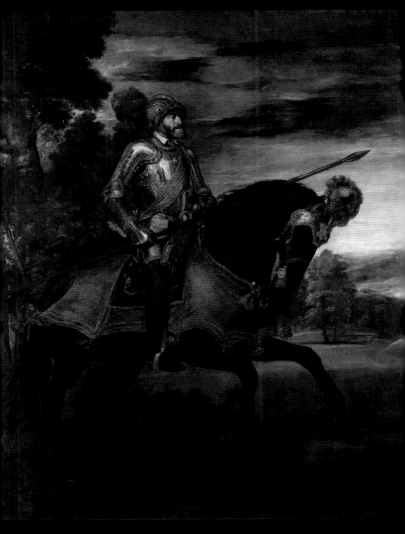

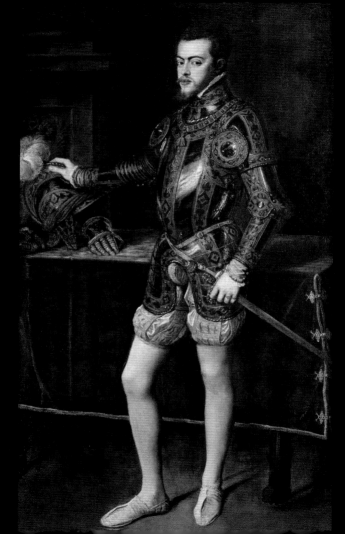

portraits, it is almost impossible to make mention of them all; wherefore I shall speak only of the most remarkable, but without order of time, it being of little import to know which was first and which later.

Several times, as has been related, he painted the portrait of Charles V, and he was lately summoned for that purpose to the court, where he portrayed him as he was in those his later years; and the method of Titian so pleased that invincible emperor, that after he had once seen it he would not be portrayed by any other painters. Each time that he painted him, he received a thousand golden scudi as a present, and he was made by his Majesty a Knight, with a revenue of two hundred scudi on the Treasury of Naples.[1] Similarly, when he portrayed King Philip of Spain, the son of Charles, he received from him a fixed allowance of two hundred scudi more; insomuch that, adding those four hundred to the three hundred that he has on the Fondaco dei Tedeschi from the Republic of Venice, he has without exerting himself a fixed income of seven hundred scudi every year. Of Charles V and King Philip Titian sent portraits to the lord Duke Cosimo, who has them in his *guardaroba*. He portrayed

1. See Aretino's letter, p. 121

Opposite: Philip II, 1551

Ferdinand, King of the Romans,[1] who afterwards became Emperor, and both his sons, Maximilian, now [Holy Roman] Emperor, and his brother. He also portrayed Queen Mary [of Hungary],[2] and, for the Emperor Charles V, the Duke [Johann Friedrich] of Saxony when he was a prisoner.[3] But what a waste of time is this! There has been hardly a single lord of great name, or prince, or great lady, who has not been portrayed by Titian, a painter of truly extraordinary excellence in this branch of art. He painted portraits of King François I of France,[4] as has been related, Francesco Sforza, Duke of Milan, the Marchese di Pescara, Antonio de Leyva, Massimiliano Stampa, Signor Giovan Battista Castaldo,[5] and other noblemen without number. As well as the works I mentioned above, at various times he has executed many others besides.

In Venice, by order of Charles V, he painted in a great altarpiece with the Trinity enthroned, Our Lady and the Infant Christ with the dove over Him, and the background all of fire, signifying [divine] love; and

1. 1548, lost. A copy in Madrid, Prado 2. 1548, lost. A copy in Paris, Musée des Arts Décoratifs 3. 1548, Vienna, Kunsthistorisches Museum 4. c.1539, Paris, Louvre 5. 1548-54, London, Simon Dickinson

Opposite: The Glory, 1551-54

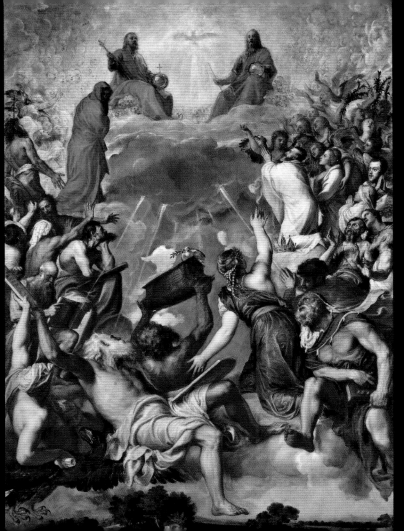

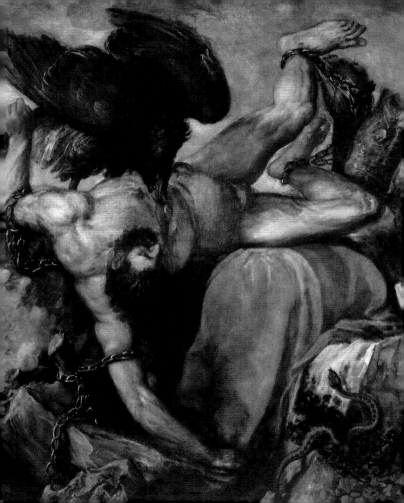

the God-the-Father is surrounded by fiery cherubim. To one side is the same Charles V, and on the other the empress, both clothed in linen garments, with the hands clasped in the attitude of prayer, among many saints; all which was after the order of the Emperor, who, at that time at the height of his victories, began to show that he was minded to retire from the things of this world, as he afterwards did, in order to die like a true Christian, fearing God and desirous of his own salvation.[1] Which picture the Emperor said to Titian that he wished to place in the monastery wherein afterwards he finished the course of his life; and since it is a very rare work, it is expected that it may soon be published in engravings. The same Titian executed for Queen Mary a Prometheus who is bound to Mount Caucasus and torn by Jove's eagle, a Sisyphus in hell who is toiling under his stone, and Tityus devoured by the vulture.[2] These her Majesty received, excepting the Prometheus, and with them a Tantalus of the same size (namely, that of life), on canvas and in oils. He executed, also, a Venus and

1. *The Glory*, 1551-54, Madrid, Prado 2. 1548-49, cycle of *Four Furies*, lost. *Tityus* (perhaps a replica of c.1565) and *Sisyphus* in Madrid, Prado. *Ixion* and *Tantalus* (perhaps by Michiel Coxie) lost in a fire (1734)

Opposite: Tityus, c. 1565

Adonis that are marvellous, she having swooned, while the youth is about to leave her, with some dogs about him that are very natural.[1] On a panel of the same size he represented Andromeda bound to the rock, and Perseus liberating her from the sea-monster, than which picture none could be more lovely;[2] as is also another of Diana, who, bathing in a fount with her nymphs, transforms Actæon into a stag.[3] He also painted Europa passing over the sea on the back of the Bull.[4] All these pictures are in the possession of the Catholic King [Philip II], held very dear for the vivacity that Titian has given to the figures with his colours, making them natural and as if alive.

It is true, however, that the method of work which he employed in these latter pictures is rather different from that of his youth, for the reason that the early works are executed with a certain fineness and incredible diligence, and can be viewed both from close up and from afar; these recent works, on the other hand, are dashed off in bold strokes, [broadly applied] in great patches [in such a manner] that they cannot be looked at closely, but from a distance appear perfect.

1. 1554-55; Madrid, Prado 2. 1554-56; London, Wallace Collection
3. 1556-59; London, National Gallery, and Edinburgh, National Galleries of Scotland 4. 1559-62, Boston, Isabella Stewart Gardner Museum

This method has been the reason that many, wishing to imitate him therein and so demonstrate their own ability, have only painted clumsy pictures; and this happens because, although many believe that they are done without effort, in truth it is not so, and they delude themselves, for one can see that they are painted over and over again, gone over and retouched many times, so that the effort [involved] may be perceived. And this method, carried out in this way, is judicious, beautiful, and magnificent, because the pictures seem to come alive and are executed with great skill, hiding the effort [and work] that went into them.

Titian painted recently in a picture three braccia high and four braccia broad, Jesus Christ as an Infant in the lap of Our Lady and adored by the Magi, with a good number of figures of one braccio each, which is a very lovely work,[1] as is also another picture that he himself copied from that one and gave to [Ippolito d'Este], the old Cardinal of Ferrara.[2] Another picture, in which he depicted Christ mocked by the Jews, which is most beautiful, was placed in a chapel of the church of Santa Maria delle Grazie,

1. 1559, Spain, El Escorial 2. c.1559-60, with workshop assistance; Milan, Ambrosiana

Overleaf: Diana and Actæon, 1556-59

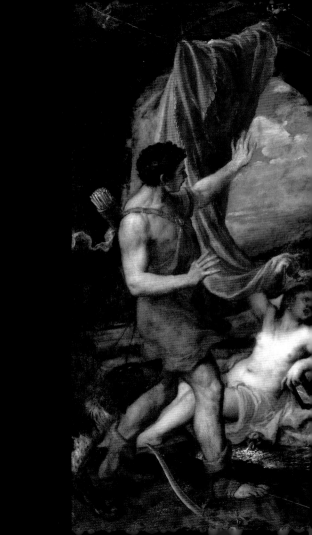

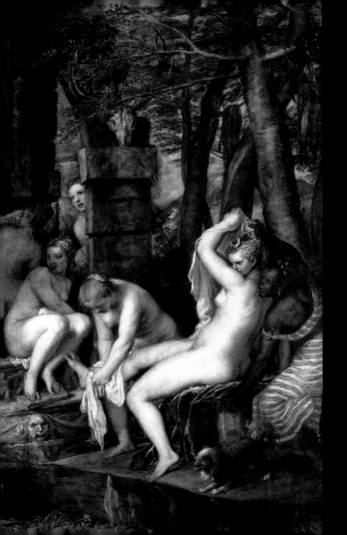

in Milan.[1] For the Queen of Portugal he painted a picture of a Christ scourged by Jews at the column, a little less than the size of life, which is very beautiful. For the high altar of San Domenico, at Ancona, he painted an altar-piece with Christ on the Cross, and at the foot Our Lady, St John, and St Dominic, all most beautiful, and executed in his later manner with broad strokes, as has just been described above.[2] And by the same hand, in the church of the Crociferi [Santa Maria Assunta] at Venice, is the picture that is on the altar of San Lorenzo, wherein is the martyrdom of that saint, with a building full of figures, and St Lawrence lying half upon the gridiron, in foreshortening, with a great fire beneath him, and about it some who are kindling it.[3] And since he counterfeited an effect of night, there are two servants with torches in their hands, which throw light where the glare of the fire below the gridiron does not reach, which is piled high and very fierce. Besides this, he depicted a flash of lightning, which, darting from heaven and cleaving the clouds, overcomes the light of the fire and that of the torches, shining over the saint and the

1. c. 1540-42, Paris, Louvre 2. 1556-58, still in situ 3. c. 1548-57, reworked; still in situ

Opposite: The Martyrdom of Saint Lawrence, c. 1548-57

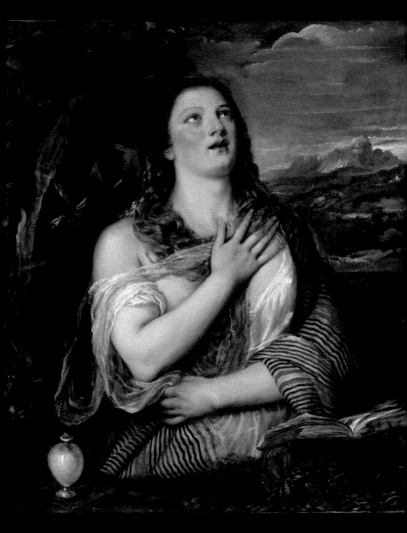

other principal figures, and, in addition to those three lights, the figures that he painted in the distance at the windows of the building have the light of lamps and candles that are near them; and all, in short, is executed with beautiful art, judgment, and intellect.

In the church of San Sebastiano, on the altar of San Niccolò, there is by the hand of the same Titian a little altarpiece of a St Nicholas who appears as if alive, seated in a chair painted in the likeness of stone, with an angel that is holding his mitre; which work he executed at the commission of Messer Niccolò Crasso, the advocate.[1] Titian afterwards painted, for sending to the Catholic King, a figure of St Mary Magdalene from the middle of the thighs upwards, all dishevelled; that is, with the hair falling over the shoulders, about the throat, and over the breast, the while that, raising the head with the eyes fixed on heaven, she reveals remorse in the redness of the eyes, and in her tears repentance for her sins.[2] Wherefore the picture moves mightily all who behold it; and, what is more, although she is very beautiful, it moves not to lust but to pity. This picture, when it was finished, so pleased (...) Silvio, a Venetian nobleman, that in order

1. 1563, in situ 2. 1561, lost in a fire (1873)

Opposite: The Penitent Magdalene, 1555-65

to have it, being one who takes supreme delight in painting, he gave Titian a hundred scudi: wherefore Titian was forced to paint another, which was not less beautiful, for sending to the said Catholic King.

There are also to be seen portraits from life by Titian of a Venetian citizen called Sinistri,[1] who was much his friend, and of another named Messer [Giovan] Paolo da Ponte, for whom he likewise portrayed a daughter that he had at that time, a most beautiful young woman called Signora Giulia da Ponte, a close friend of Titian; and in like manner Signora Irene [di Spilimbergo], a very lovely maiden, skilled in letters and music and a student of drawing, who, dying about seven years ago, was celebrated by the pens of almost all the writers of Italy.[2] He portrayed Messer Francesco Filetto, the orator of happy memory, and in the same picture, before him, his son, who seems as if alive;[3] which portrait is in the house of Messer Matteo Giustinian, a lover of the arts, who has also had commissioned a picture from the painter Jacopo da Bassano, which is very beautiful, as also are many other works by that Bassano which are dispersed

1. c.1545-50; possibly the painting in San Francisco, Fine Art Museums 2. c.1560, Titian's studio and/or Gian Paolo Pace; Washington, DC, National Gallery of Art 3. c.1540, split in two canvases; Vienna, Kunsthistorisches Museum

throughout Venice, and held in high regard, particularly his little figures and animals of every kind.*

Titian portrayed Bembo another time (namely, after he became a Cardinal),[1] [Girolamo] Fracastoro, and [Benedetto] Accolti [the Younger], Cardinal of Ravenna, which last portrait Duke Cosimo has in his guardaroba; and our Danese [Cattaneo], the sculptor, has in his house at Venice a portrait by the hand of Titian of a gentleman of the Dolfin family.[2] There may be seen portraits by the same hand of Messer Niccolò Zeno,[3] of Rossa [i.e. Hurrem Sultan], wife of the Grand Turk, at the age of sixteen, and of Cameria [i.e. Princess Mihrimah Sultan], her daughter, with

*AC: *This Jacopo Bassano was a painter who deserved far more praise than he got from Vasari, because apart from other most beautiful paintings of his he made those miracles which it is said were made by the ancients, Zeuxis and others (...) with the greatest of ease deceiving not so much animals, but men, even of our profession; and I can bear witness to this because I was deceived by him once, being in his workshop and stretching out my hand to pick up a book which was on a chair, and which seemed to me of considerable size, I realised that I was grasping a small piece of paper (cartonzello), on which a book was depicted, foreshortened with such artifice that it unquestionably seemed to me to be a true thing, appearing to be four times [bigger].*

1. 1539, Washington, DC, National Gallery of Art; or c.1545–46, Naples, Museo di Capodimonte 2. Possibly *Portrait of Jacopo Dolfin*, c.1531, Los Angeles County Museum of Art 3. c.1560, Kingston Lacy, Bankes collection

most beautiful dresses and adornments. In the house of Messer Francesco Assonica, an advocate and comrade of Titian, [there] is a portrait by his hand of that Messer Francesco, and in a large picture Our Lady fleeing to Egypt, who is seen to have dismounted from the ass and to have seated herself upon a stone on the road, with St Joseph beside her, and a little St John [the Baptist] who is offering to the Infant Christ some flowers picked by the hand of an angel from the branches of a tree that is in the middle of a wood full of animals, where in the distance the ass stands grazing.[1] That picture, which is full of grace, the said gentleman has placed at the present day in a palace that he has built [for himself] at Padua, near Santa Giustina. In the house of a nobleman of the Pisani family, near San Marco, there is by the hand of Titian the portrait of a noblewoman, which is a marvellous thing. And having made for Monsignor Giovanni della Casa, the Florentine, who has been illustrious in our times both for nobility of blood and as a man of letters, a very beautiful portrait of a noblewoman whom that gentleman loved while he was in Venice, [Titian] was rewarded by being honored by him with the lovely sonnet that begins:

1. Possibly the painting in El Escorial

Well do I see, Titian, in a new guise
My [beloved] idol, opening her beautiful eyes and
 turning [her gaze to me]
(with what follows).

Recently, this excellent painter sent to the said Catholic King a [Last] Supper of Christ with the Apostles, in a picture seven braccia long, which was a work of extraordinary beauty.[1]

In addition to the works described [above] and many others of less worth executed by this man, which are omitted for [the sake of] brevity, he has in his house, sketched in and begun, the following: the Martyrdom of St Lawrence, similar to that described above, and destined by him for sending to the Catholic King;[2] a great canvas wherein is Christ on the Cross with the thieves, and the executioner below, which he is painting for Messer Giovanni d'Anna;[3] and a picture which was begun for the Doge [Antonio] Grimani, father of the Patriarch of Aquileia [Domenico Grimani].[4] And for the hall of the grand Palazzo [della Loggia] of Brescia he has made a beginning with three large pictures that are to go in the ornamentation of

1. 1557-64, Spain, El Escorial 2. 1564-67, Spain, El Escorial
3. c.1565; possibly the largely unfinished fragment in Bologna, Pinacoteca Nazionale 4. c.1555, but completed by an assistant after Titian's death; still in situ

the ceiling, as has been related in speaking of Cristoforo [Rosa] and his brother [Stefano], painters of Brescia.[1] He also began, many years ago, for Alfonso I, Duke of Ferrara, a picture of a nude young woman bowing before Minerva, with another figure at the side, and a sea in the centre of which, in the distance, is Neptune in his chariot; but due to the death of that lord, after whose fancy the work was being executed, it was not finished, and remained with Titian.[2] He has also carried well forward, but not finished, a picture wherein is Christ appearing to Mary Magdalen in the Garden in the form of a gardener, with figures the size of life;[3] another, also, of similar scale, in which the Madonna and the other Marys being present, the Dead Christ is laid in the sepulchre;[4] likewise a picture of Our Lady, which is one of the best things that are in his house,[5] and, as has been said [above], a portrait of himself that was finished by him four years ago, very beautiful and natural; finally a St Paul who is reading, a half-length figure, which has all the appearance of the real saint filled with the Holy Spirit. All these

1. 1564-68 with workshop assistance; lost in a fire (1575) 2. Possibly painting in Madrid, Prado, c.1534 (first version), 1570-75 (second version) 3. Similar to the composition for Mary of Hungary: 1553, a fragment in Madrid, Prado 4. 1559, Madrid, Prado (no. P440). 5. c.1565; possibly the painting in El Escorial

works, I say, he has executed, with many others that I omit in order not to be wearisome, up to his present age of about seventy-six years.

Titian has been very sound in health, and as fortunate as any man of his kind has ever been; and he has not received from heaven anything save favours and blessings. In his house at Venice have been all the princes, men of letters and persons of distinction who have gone to that city or lived there in his time, because, in addition to his excellence in art, he has shown himself to be a great gentleman with the most courteous ways and manners. He has had in Venice some competitors, but not of much worth, so that he has surpassed them easily with the excellence of his art and with his ability to entertain and making himself dear to noblemen.*

He has earned much, for he has been very well paid for his works; but it would have been well for

* AC: *Oh, listen to the devil – he says that Titian's rivals were of no value, namely Giorgione, Pordenone, Tintoretto, Giuseppe Salviati, Paolo Veronese, and Palma Vecchio, who were all painters of great importance, but he nonetheless outdid them; but if he had to compete with the Ghirlandaio [family], [Agnolo] Bronzino, [Filippo and Filippino] Lippi, [Niccolò] Soggi, [Giovanni Antonio] Lappoli, [Gerolamo] Genga, [Giuliano] Bugiardini and other Florentines of his, obscure in both name and work, he could easily outdo them if he painted with his feet, though with the exception of the divine Michelangelo and Andrea del Sarto.*

Overleaf: The Entombment, c. 1562-72

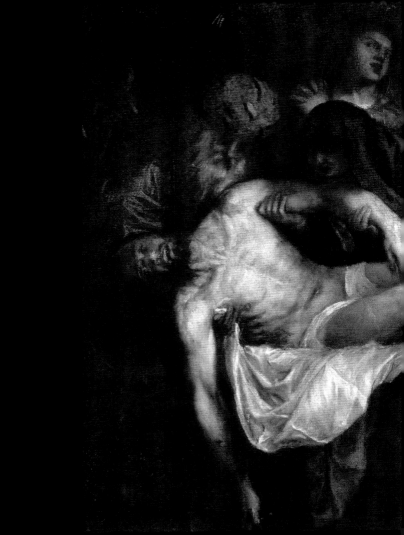

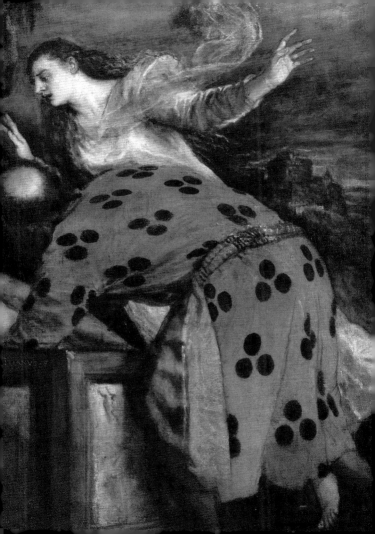

him in these his last years not to work save as a pastime, so as not to diminish with works of less excellence the reputation gained in his best years, when his natural powers were not declining and drawing towards imperfection. When Vasari, the writer of this account, was at Venice in the year 1566, he went to visit Titian, as one who was much his friend, and found him busy painting, with brushes in his hand, although he was very old; and he had much pleasure in seeing his works and discoursing with him. He introduced to Vasari Messer Giovan Mario Verdizotti, a young Venetian gentleman full of talent, a friend of Titian and passing able in drawing and painting, as he showed in some landscapes of great beauty designed by him. This man has by the hand of Titian, whom he loves and honours as a father, two figures painted in oils within two niches, an Apollo and a Diana.

Titian, then, having adorned with excellent pictures the city of Venice, nay, all Italy and other parts of the world, deserves to be loved and revered by the artists, and in many things to be admired and imitated, as one who has executed and is still executing works worthy of infinite praise, which shall endure as long as the memory of illustrious men may live.

FRANCESCO PRISCIANESE

Supper and conversation
in Titian's house

from

On the first principles of the
Roman language

1540

TO THE VERY REV. MESSER LUDOVICO BECCI AND HIS FRIEND, MESSER LUIGI DEL RICCIO

On the Kalends of August[1] I was invited to celebrate the kind of Bacchanal which, I know not why, is called *ferrare Agosto*,[2] – we argued about this for much of the evening – in a delightful garden belonging to Messer Tiziano Vecellio, the excellent Venetian painter (as everyone knows), a person truly suited to spice every worthy feast with his pleasantries. There were gathered together with the said Messer Tiziano (because birds of a feather flock together) some of the most rare intellects that are found today in this city, and from our set principally Messer Pietro Aretino, the new miracle of Nature, and beside him Messer Jacopo Tatti called Sansovino, who is as great an imitator of Nature with his chisel as is our host with his brush, [and] Messer Jacopo Nardi and myself, so that I was the fourth amongst so much wisdom. Here, before the tables were set out, because the sun despite the shade was still making his heat much felt, we spent the time admiring the lifelike images in the excellent pictures which filled the house and in

1. 1st of August 2. *Ferrare* means 'to shoe [a horse]', but in fact *ferragosto* derives from *feriæ Augusti* – holidays of (Emperor) Augustus

Opposite: Two Satyrs in a Landscape, c. 1505-10

discussing the rare beauty and loveliness of the garden, which everyone marvelled at with singular pleasure. The garden is situated on the far end of Venice by the edge of the sea, and from it one sees the pretty little island of Murano and other lovely places. As soon as the sun set, this part of the sea teemed with a thousand of little gondolas adorned with beautiful women and resounded with the varied harmonies and melodies of voices and musical instruments which accompanied our delightful supper until midnight. But, to return to the garden, it was so well laid out and so beautiful, and as a result received so much praise, that the resemblance that came to my mind was to the most beautiful gardens of Sant' Agata, belonging to our most reverend patron Monsignor Ridolfi[1] (insofar as small things can be compared to the great). This evoked to me such a clear memory of his most reverend Lordship and the desire for those [gardens], and to be with you, my dearest friends, that for most of the evening I could not quite discern whether I was in Rome, or in Venice, almost foreshadowing what happened shortly afterwards. Indeed, having

1. The Florentine Cardinal Niccolò Ridolfi (1501-1550) was the son of Contessina de' Medici, the daughter of Lorenzo the Magnificent, and therefore nephew of Pope Leo X

started to think about [the garden at Sant' Agata], I was obliged to talk about it and describe, bit by bit, the whole site, the appearance, the disposition and the elegance of that garden, which you are enjoying without me. Then everyone [present] started to praise and compete with one another in magnifying the nobility of mind, as well as the kindness and humanity of its owner. But Messer Jacopo Nardi promptly turned the conversation to a truer and more honoured praise of his most reverend Lordship, recounting many things about the affection and liberality towards men of virtue, and of the sincerity of soul and singular charity towards his homeland shown in everything he does. Meanwhile, there came the hour for supper, which was no less fine and well-presented, as abundant and well-stocked, with not only the very finest dishes and most precious wines but also all those pleasures and amusements that matched the quality of the weather, the individuals and the party itself. And with the meal now having reached the fruit course, there arrived your most delectable letters, like more of the sweetest fruit that might be lacking in the completion of the splendid banquet, brought me from home by Giovan Battista Brussa, my Tiro.[1] I could not hold back from

1. Secretary; as in Marcus Tullius Tiro, Cicero's assistant

Sacred and Profane Love, c. 1515-16

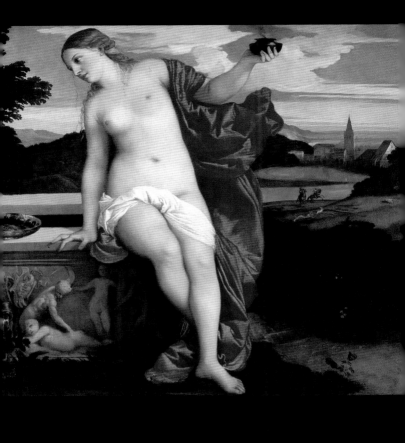

opening and reading them before everyone, knowing how much their customary pleasure would have entertained those present, as happened when they heard about your lovely dinner in the garden of the Reverend Lord [Cardinal Ridolfi], so praised by us, and the sweet conversations you had recalling our own most sweet friendship. However, some were quite indignant at the great incivility (not to mention malice) of that thorny grammarian (as you call him) who between the pleasures of dinner and the sweetness of your friendship went stirring in the bitterness of grammatical questions. But above all Aretino fretted like a demon when he heard the Tuscan language being censured; and if he had not been held back, I think that at that very moment he would have put his hand to one of the most cruel invectives in the world, furiously calling for paper and an inkwell – though he did not fail to do a good deal with the spoken word. Finally the supper ended on a happy note…

PIETRO ARETINO

Letters about Titian

from
the first, fourth and fifth books of letters

1538, 1548 and 1550

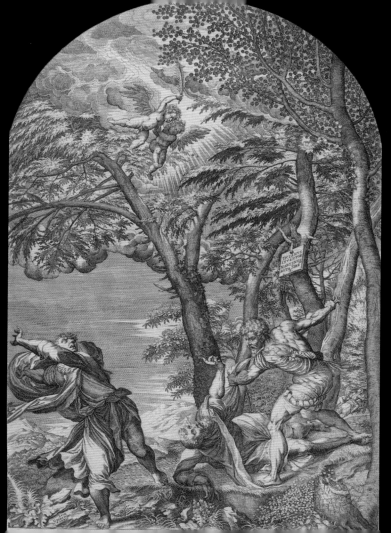

Pietro Aretino to the sculptor and architect Niccolò dei Pericolo, called Il Tribolo, discussing the Death of Saint Peter Martyr, *formerly Venice, Church of Santi Giovanni e Paolo*

Knowing the great delight [I take] and the small judgment I possess in sculpture, the architect Messer Sebastiano [Serlio] has made it possible for me to see from the words [of his description] the flowing folds of the robe of the Virgin created in my honour by your intellect, driven by your good will. He has also told me how languidly fall the limbs of the dead Christ, whom you have placed in her lap in so masterly a pose; and so therefore I have seen the affliction of the mother and the wretchedness of her Son, even before setting eyes on the work itself. While Sebastiano was recounting to me the miracle wrought by your manner and diligent ingenuity, [here came] the painter of the Saint Peter Martyr, which when you saw it filled you and Benvenuto [Cellini] with such astonishment; and resting your own eyes on it, and the eyes of your soul, you realized all the living terrors of death and all the true sorrows of life in the

Opposite: Death of St Peter Martyr, after Titian, c. 1560

face and flesh of the fallen saint, and marvelled at the cold and livid appearance of the tip of the nose and the extremities of the body. You were unable to restrain your voices, and you exclaimed aloud as your gaze fell on the fleeing [figure of his] companion in whom you perceived the whiteness of cowardice and the pallor of fear. Truly, you gave a true assessment of the merit of this great picture, when you told me that it was [nothing but] the most beautiful work in all Italy. What a wonderful group of little boys stands out in the air against the trees, through the branches and leaves of which [one may see] the passing sky! What a landscape composed with all the simplicity of Nature! What mossy rocks that are bathed by the water, which is sent flowing by the spring that gushes from the brush of the divine Titian! And he and his benign modesty greets you most warmly and offers himself and all he has, swearing that nothing can equal the love that his affection feels for [you and] your reputation. Nor can I say with what impatience he waits to see the two figures which, as I said above, you have deliberately decided to send me; a gift which will not be passed over in silence or ingratitude.

VENICE, 7 NOVEMBER 1537

Pietro Aretino to Veronica Garbara, Lady of Corregio

My elegant lady, I am sending you the sonnet you requested, which my fancy has created driven by Titian's brush. Because just as he could not portray a more praiseworthy prince, so I should not have to apply my intellect in [writing] any less honoured portrait. Seeing it, I summoned Nature as a witness, making her confess that art was turned into [Nature] herself. Evidence of this lies in every wrinkle, hair and mark, and the colours painted here prove not only the fieriness of the flesh [of the sitter] but [also] reveal the manliness of his soul. The vermilion of the velvet placed behind him as an ornament is reflected in the shiny armour he wears; and a fine effect, too, comes with the plumes of his sallet, with their vivid reflections in the polished cuirass of that great leader. Even the batons of his generalships are natural, especially that [of the soldier] of fortune, which flower so much [for no reason other than] to give proof of his glory, which began to scatter the rays of virtue in the war that belittled [Pope] Leo [X]. Who would not say that the batons he received from the Church, Venice and Florence, were not of silver itself? How much hatred must Death bear toward the sacred spirit that resurrects the

people she has slain! His Imperial Majesty [Charles V] knew this well, when in Bologna he saw himself alive in a portrait, and marvelled at it more than at the victories and triumphs that could easily bring him to heaven. Now read this [sonnet] along with another one attached, and then resolve to commend my desire to celebrate the Duke and Duchess of Urbino, and not praise the style of such feeble verses.

> If the eminent Apelles with the hand of art
> A likeness gave of Alexander's face and breast,
> He did not show the exalted vigour
> Emitted by the soul of this rare subject.
>
> But Titian, more greatly gifted by heaven,
> Makes visible every invisible concept;
> Thus the great Duke in his painted aspect
> Reveals the palms [of victory] adorning his heart.
>
> Dread conveyed between his eyebrows,
> His soul is in his eyes, his brow all loftiness,
> Where honour lies, and all good counsel.
>
> In his armoured bust, and in those ready arms,
> Burns valour, which guards from peril
> Italy, who is devoted to his renowned virtues.
> The harmony of colours, that the brush
> Of Titian applied, expresses outwardly

Opposite: Portrait of Francesco Maria della Rovere, c. 1537

The concord ruling Eleonora
And the virtues administering her gentle soul.

Modesty humbly sits beside her,
Honesty in her clothing dwells,
Decorum veils and honours her bosom and her hair,
And Love builds her lordly gaze.

Chastity and Beauty, eternal foes,
Move across her countenance, and between her brows
The throne of the Graces may be discerned.

Prudence oversees her merits and counsels
Her in wondrous silence, [while] the other virtues,
Those within, beauteously adorn her face.

VENICE, 10 JULY 1539

Pietro Aretino to Ottaviano de' Medici. Discussing the Emperor's concession to Titian of income from 300 carra of grain

The goodness of God is invoked by men because of the graces that rain down from the heaven of his mercy, and Your Lordship's favour is sought by virtuosi [those of the highest talent] for the honourable use which continuously guides [your] talent in being pleased by their enjoyment of it. Thus Messer Titian,

Opposite: Portrait of Eleonora Gonzaga, Duchess of Urbino, c. 1537

a painter no less pleasant than he is divine, trusts in your benign nature fully, and with hope in it he is of the firm opinion that he should achieve what he wishes by way of your mediation. My only wish is for his [satisfaction], as he may go there [Florence] immediately and with his art leave eternal memory of the likeness of the Duchess [Eleanor of Toledo], the Duke [Cosimo de' Medici], Signora Maria [Salviati], and yourself. His Imperial Majesty [Charles V], to whose benign person Titian's service owes no small part, gave him the [income from the] trade in two hundred carra of grain in the Kingdom [of Naples], and since it seemed little to him he added a hundred more, but circumstances and his own hard luck delayed the expected shipment that should have been done by the Viceroy [Pedro de Toledo], who is such a generous Prince that as soon as his most excellent son-in-law and daughter [Duke Cosimo and Duchess Eleanor] write a letter to him on this particular matter, it will bring peace of mind, and he will adorn your house with his works. To move your nobility to an act of such high office, I could introduce some of the qualities of my comrade's merits; but I shall remain silent so as not to offend the humanity of the magnificent Ottaviano, and not lessen the grade of the eminent Titian, so that the one obeys his nature

in helping worthy individuals, and the other is so well known that he does not need the praise of others. In any event, as soon as you have succeeded in this benefice, Titian will have sent to you, or rather he will bring, two miracles [crafted] by his hand that will astound any judgement. Now I await that you may deign to respond with something to console both him and me.

VENICE, 20 NOVEMBER 1540

Pietro Aretino to Alfonso d'Avalos, Marquis of Vasto. Discussing The Allocution of Marchese del Vasto *(Madrid, Prado)*

[...] Now to come to the lateness of Titian, who has given grateful recognition of the benefits received from the courteous goodness of [the Marchese del] Vasto. The fact that he was held back in Mantua caused the delay, which has come between your wishes and his debt to you. Yesterday he took me to see the painting in which you are seen addressing your troops from a pier. I swear to you on all the honours you have, that although the painted figures are only there in surface appearance, the brush of this admirable man with such a new manner forms the parts that cannot be seen [yet] in the image of yourself, that he

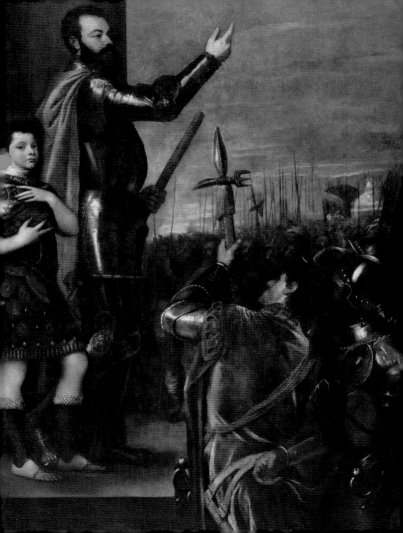

is colouring; and this [image], in which you appear so fully in the round as if you were alive, reveals Alfonso [himself] rather than showing the steel [of your armour], despite the fact that such a great painter arms you with what looks so much like real steel that it would be impossible to discern the natural from the artificial, since the reflections of the metal plates glow and flash, and flashing and glowing they wound the eyes that admire them, so they become not just dazzled but blinded. Meanwhile you could almost swear that the multitude of soldiers who stand in stupefied silence, variously dressed and armed, are moving their gaze from the majesty enthroned upon your golden brow, only to contemplate Francesco Ferdinando, sole splendour of the rays of your glory. Whoever admires how Vecellio has portrayed such a grand son next to a father of such high rank, can judge not in what manner an angel stands next to God, which would be a rash thing to say, but with what gesture Phoebus came to the side of Mars when the purity of his nine years flourished in him, with that grace with which such a simple age flourishes in your illustrious firstborn. His holding the sallet parted by feathers, which as they are shown as windblown seem imbued with natural

Opposite: The Allocution of the Marquis del Vasto to his Troops, c. 1540-41

softness, is so directly vivid that the boy, endowed with a heavenly disposition, breathes with happiness, no less than he would if you gazed at him in flesh and blood. Hence I am certain that as soon as you see him, dressed in dexterous and ancient armour, adorned with pearls and gems, and with his arms and legs revealed, as in the Roman heroes we see on [triumphal] arches, you will want him to have such a suit. I will not speak of the air and clouds in this excellent narrative [*historia*]; nor of the landscapes painted by my comrade, no less a brother, nor of hair, beards, or draperies on the figures; because crafting such things is so natural to him that Nature confesses he is her superior rather than her equal.

VENICE, 25 DECEMBER 1540

Pietro Aretino to Nicolò Molin, Venetian nobleman. Discussing the portrait of Vincenzo Cappello *(Washington, DC, National Gallery of Art), which conveys Cappello's valour in the naval conflict of 1538 between the Holy League, including Spain (Cæsar), the Papacy (Peter) and Venice (Mark), and the Ottoman Empire*

My Lord, even though my composing verses and rhymes is as much an insult to the Muses who support it as it is a disapproval to myself, who compose them,

seeing that Titian has admirably portrayed the admirable Vincenzo Cappello, I could not help but write a sonnet about it, as follows. For more centuries will pass than we have lived years before God allows this city to be adorned by such an excellent Senator and such a noble painter. But if any glimmer of poetry appears in the gloom of such prattle, give credit to its subject, whose divinity has prompted my ingenuity, as a spur does to a lazy and hopeless horse, or the blowing of wind does to a small fire. Certainly the majesty of the sitter's looks and the excellence of the painter's colouring move any beholder, so they have to exclaim their praises, by either the tongue or the pen. Hence I may be pardoned if (having understood this from the great man's likeness) I have attempted to express those manoeuvres, which – to the benefit of his fatherland, the glory of religion, and the memory of himself – made his counsel grave and his soul undefeated at [the battle of] Preveza. But if by virtue of such actions the good old man lives on in the heart of those who never saw him, what must he do in that of yours, his nephew?

Venice, on the holy day of Christmas, 1540.

That illustrious mind and ardent valour
(As Cæsar knows, with Peter and Mark)

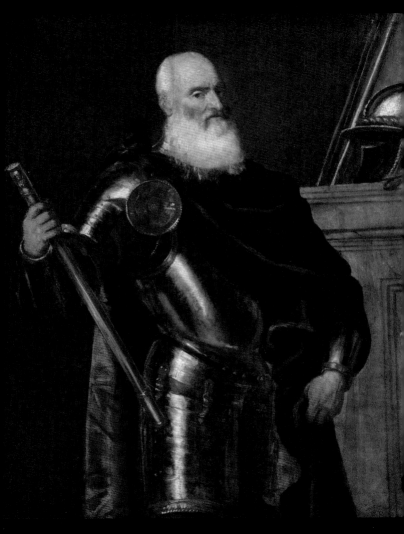

Shown by great Cappello on the briny sea,
Causing tremor to the Orient's bark,

Shines forth from this most excellent image
Moved by its own most welcome spirits,
So vividly formed by Titian,
That each of them breathes and knows and feels.

Yet you can see in it (beyond the intellect,
Beyond the zeal with which he persuaded Doria
To take wing and strip power from the Turk)
How he armed himself for Christ, and to what glory
He raised his fatherland, and how to this most
 worthy man
the inability to fight gave victory.

VENICE, 6 JULY 1542

Pietro Aretino to Titian. Discussing the Portrait of Clarissa
Strozzi *(Berlin, Gemäldegalerie)*

I have seen, my comrade, your portrait of the little
girl of Signor Roberto Strozzi, a solemn and excel-
lent gentleman; and as you seek my opinion, I will
tell you that if I were a painter I should despair, even

Opposite: Vincenzo Cappello, painted with workshop assistance, c. 1540

129

though my vision would have to have a divine aware-
ness in order to understand the reason why I should
be moved to such despair. It is certain that your brush
has maintained its miraculous power in the maturity
of old age. Hence I, who am not blind about such
qualities, swear with all my conscience that it is im-
possible to believe, let alone do, such a thing; and
therefore it deserves to be preferred to any picture
that ever was, or ever will be, painted. Nature would
swear that such a likeness is not counterfeited, if Art
implied that it is not alive. I would praise the little dog
she caresses, if it were enough to exclaim how lively
he is. I conclude this [missive] in a state of astonish-
ment, and I am left speechless.

VERONA, JULY 1543

Pietro Aretino to Titian. Discussing the Portrait of Pope Paul III,
Naples, Capodimonte Museum

Fame, my singular comrade, takes such great pleas-
ure in proclaiming the miracle made by your brush
in the portrait of the Pope [Paul III], that if it were
not for my obligation to announce to all the world the

Opposite: Clarissa Strozzi, 1542

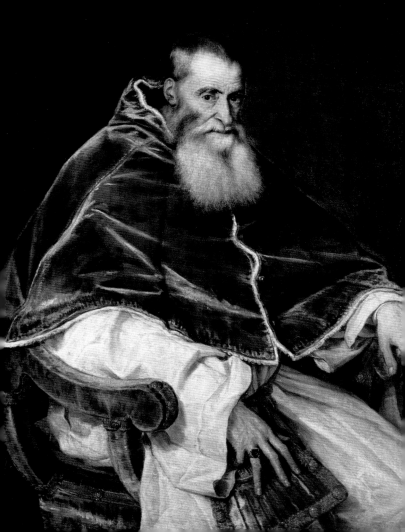

generosity of spirit you showed in refusing the office of the Seal of State, which His Holiness thought of giving you as a reward for it, I could never have trumpeted enough how alive the portrait is, how like him, how true to him it is. But all your other work, albeit divine, must give way to the act of declining to accept what anyone else would have been happy to obtain. Your not wishing to obtain the title [Keeper of the Seal of State] offered you show how inferior Rome is to Venice in excellence and beauty, and how a secular habit has more worth than the vile robes of a friar. Beyond these things, the goodness of your heart should be praised in speech and in writing, as should your integrity in not impoverishing two people in order to enrich yourself; because you would have had to take a part [of the stipend] from one [Sebastiano del Piombo], and a part from another [Giovanni da Udine], in making yourself an associate of both. Thus your great labours would have been remunerated without any cost to the person [i.e. the Pope] who ought to pay for it. But long live Vecellio!, since he appreciates a good name more than some grand income.

Opposite: Pope Paul III, 1543

PIETRO ARETINO

Pietro Aretino to Titian. Describing Venice and the Grand Canal from the balcony of his house

Signor [Titian, my] comrade, having, contrary to my usual custom, supped alone, or rather in the company of the pains of this tiresome quartan-ague, which will not permit me to enjoy the taste of any food, I rose from table full of that despair with which I had sat down before it; and then leaning my arm on the parapet of the window, and upon that having rested my breast and nearly the whole of my body, I drew my attention to the wondrous parade of a myriad boats, full of foreigners as well as inhabitants of the city, which entertained not only the people assembled [on the banks], but [also] the Grand Canal itself, a delight to everyone cutting through its waters. And as soon as it ended the entertainment of two gondolas with which two famous water men had a regatta, I greatly enjoyed myself watching the multitude, who had gathered to see the regatta on the bridge of the Rialto, on the bank of the Camerlenghi, in the Pescheria, on the Santa Sofia ferry, and in the Casa da Mosto. And whilst this crowd and those [gondolas], after joyful shouts of applause, were gradually

dispersing, each their own ways, like a man who has begun to be bored with himself, not knowing what to do with his mind and his thoughts, I lifted my eyes to the sky, which never, since the day on which God created it, was adorned by such beautiful painting of lights and shades. The air was of the kind that would be rendered by those who envy you because they cannot be you. Now try to see, in my recounting of it, first the houses, which though made of solid stone seemed to be of unreal substance. And then imagine the atmosphere I perceived, in some parts limpid and fresh, in others turbid and sombre. Imagine also the wonder I felt [at the sight] of those great clouds, masses of condensed humidity: partly low in the foreground, resting on the roofs of the houses, and partly in the middle distance, so that the right [of the scene] was all shaded off into greyish blacks. I was amazed by the variety of colours revealed in those [clouds]: those in the foreground were ablaze with the flames of the sun; those farther off, less ignited, glowed with the subdued heat of red-lead. Oh, with what beautiful strokes did Nature's brush sweep back the atmosphere, clearing it away from the palaces in the way that Titian distances it in his landscapes! In certain areas there appeared a bluish green, and in others a greenish blue, truly mixed by the fancy of Nature, the

mistress of masters. With lights and darks she created the effects of distance and relief in such a manner that I, who know how your brush is the very soul of her spirits, cried out three or four times: "Oh, Titian, where are you now?" For I swear that if you had painted the scene I have described, you would have provoked the same astonishment in men that so confounded me; I have nourished my soul in contemplating what I have just related to you, [but] my wonder [at this scene] could last only as long as [the short life of] a painting of that sort.

VENICE, MAY 1544

Pietro Aretino to Jacopo Sansovino. Describing the portrait of Giovanni de' Medici delle Bande Nere

As soon as ever Titian can paint it with his colours, in order that you, Messer Jacopo, may carve it in marble, I will send you the head of Signor Giovanni [de' Medici, called Giovanni delle Bande Nere], because he who performed so much with his war-like hands, that the learned languages can hardly praise him enough, deserves to have his image revived by the power of your chisel. I will not advise you to give him youth, as death has made his face look old, because

you are accustomed to be wise enough when carving your figures. But although he looks to be forty, bear in mind that the noble youth was [only] twenty-eight on the night of the last day he lived.

VENICE, OCTOBER 1545

Pietro Aretino to Titian. Mentioning Aretino's portrait (Florence, Palazzo Pitti) and telling Titian about the artists in Rome during his sojourn there

Though I am angry with you for me having to collect the bust of the head of Signor Giovanni [de' Medici], without its being painted by your hand, together with my own portrait rather sketched than finished, yet your letters are still very dear to me; and especially when you tell me of the tears which bathe the eyes of [Cardinal Pietro] Bembo as soon as you gave to his most Reverend Lordship the regards that I, his devoted servant, sent him. And as he was so kind as to shed tears only hearing of my regards from your voice, I in return shed tears hearing of his by your letter. I could not help being touched in the depths of my heart by the most honourable reception you received from His Holiness the Pope [Paul III], Our Lord. But it is the peculiar charm of the house of Farnese to be lavish

of caresses but, as everyone knows, they are mother to those expectations that nature most excellently invented to please [the appetites of] those persons who are always ready to buoy themselves up with promises, even [when being left] in the greatest doubt [they will be satisfied]. I do well believe that you pity yourself for the whim that has now seized you of going to Rome, did not happen twenty years ago. If you are surprised at its present state, what would you have been, had you seen it in the condition that I left it? You should know that this great city, in all its calamities, resembles an excellent prince returned from exile, who, though tormented by the disadvantage of poverty, still preserves his status by virtue of his royal liberality. Hours seem to last months as I wait for your return, if it be only to hear what you think of the antique marbles, and in what respect [Michelangelo] Buonarroti surpasses or is inferior to them, and [if you think] he has more or less skill in painting than Raphael. I shall enjoy conversing with you about Bramante's construction of Saint Peter's; and the works of all the other architects and sculptors. Please recall the manners of all the famous painters, and particularly that of our Fra Sebastiano [del Piombo]; look well at every intaglio in bùccino [perhaps the murex], and do not forget to contrast mentally the figures of

our comrade Messer Jacopo [Sansovino] with the statues of those [artists] who hardly can rival with him and are understandably blamed [for trying]. In short, inform yourself of the manners of the [Papal] court and the courtiers, as well as the arts of painting and sculpture. Especially draw your attention to the works of Perino del Vaga who has a beautiful mind. In the meantime remember not to be so lost in the contemplation of the [Last] Judgement in the [Sistine] Chapel, as to forget to make haste back, that you may not be absent all the winter from me and Sansovino.

VENICE, DECEMBER 1547

Pietro Aretino to Titian. Titian is invited to dinner with the courtesan Angela Zaffetta and the medallist Luigi (Alvise) Anichini

A brace of pheasants, and I know not what else, await you at dinner, with Signora Angela Zaffetta and myself; so you should come, because if we continue to enjoy ourselves, senility – the gauge of mortality – can never tell death that we have aged. So if we both transform old age with the mask of youth, it won't soon notice the weight of our years, and they will change from ripe to green again, as the elderly live

their lives agreeably. Come over, then, and if Luigi
Anichini wants to join you, I would love it dearly.

VENICE, FEBRUARY 1548

*Pietro Aretino to Titian. Mentioning Titian's arrival at the
Imperial Court in Augsburg*

Messer Titian, no less a brother to me than you are
a comrade, the letter you wrote to me with the hand
that competes only with Nature in making a likeness
of everything visible, so closely imitating the spirit that
lives hidden in each of her creations, that she herself
is in doubt as to which of the two of you is greater and
better – a letter desired as much by me as any other I
ever craved – has truly given me such happiness that
it cannot be expressed, solely because it brought me
certainty that you had arrived in Augsburg safe and
sound. This really is the grace of God, given the in-
clement weather of this season, and of such odd and
irritating detours. I will not speak of the welcome
afforded you by the Emperor: if one wishes to un-
derstand how his affectionate clemency received your
individual virtues, and with what pleasure – being
a man of talents and virtues [virtuoso] – you received
His great charitableness, one only need think of how

Alexander [the Great] received his Apelles, and how Apelles presented himself to his Alexander. My consolation now lies in looking forward to enjoying the fruits of His Exalted Majesty's largesse before your sublime merit.

VENICE, APRIL 1547

Pietro Aretino to Orazio Vecellio, Titian's son. Congratulating Orazio on his recent marriage

That Lucrezia – of all the Madonnas who doubled the embellishment of your wedding – should be considered a modest damsel is no surprise, though it seems incredible. Because a public harlot is never a good woman, unless chance leads her to a place with a multitude of maidens who are of the most honest and chaste repute. In which case, admiring their faces in the mirror of the others' continence, they [i.e. harlots] are so embarrassed by their blushing that they dare not bat an eyelid beyond what is deemed modest; so it is praiseworthy to invite them to banquets and balls, where they are joined by daughters and sisters, as well as nieces and relatives.

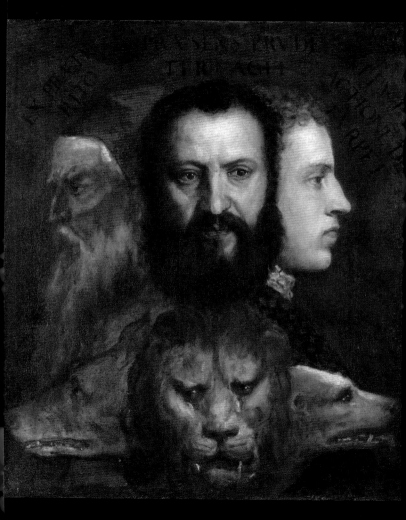

VENICE, SEPTEMBER 1550

Pietro Aretino to Pomponio Vecellio, Titian's eldest son. Reproaching Pomponio for loose living

It is true that Old Age seems a fable to Youth, just as it is no lie that Youth sounds like a story to Old Age. Just as the former laughs at what calls for weeping, so the latter weeps about what should be laughable. I enter into this subject because of the mockery made on your part of the admonitions made by someone [old] like me. Your father saw me yesterday evening (at my house, I mean), but so distressed in spirit that I suffered what he was suffering. And it all comes from the existence you lead, which the great man wishes would change in you. Your life is certainly suited to a piece of theatre in which the players are not wary of entertaining for too long a time those who listen to them, but [rather] of how well they recite on stage. Now since the punishment for failure is the reparation of error, go and revisit your intellect a little, as it is so fine that if you exercised it in studies, you would find yourself among the learned, an equal among them all. It is not fair that such a worthy faculty as yours, obtained by

Opposite: An Allegory of Prudence, c.1560-70

143

virtue of Titian's brush, and by his efforts, wisdom, and journeys, should be thrown away in pleasures. Rather, you would be lauded by enhancing and doubling it. So return to your books, leaving lasciviousness aside; and may you be repelled by rotting in idleness, when its laziness generates lust. Read others' poetry in your own, since reading nourishes the intellect, and if that becomes confused, it will be restored [by reading]. Compose yourself, proceeding in each commendable thing, so that people envy you for your reputation rather than pity you in reproach. There is no doubt that someone who does not know how to take advantage of himself, while being scolded by his own conscience and soul, is like a sick body with a certain laziness in the nerves, a lassitude without fatigue, a trembling in the limbs, and such frequent yawning, that one believes one is dying while living. Now when you want to return to the path I wish and ardently desire for you, and which you know and owe [to yourself], I shall so importune my Comrade [Titian] that my fervent prayers will win over not only his stubbornness but his oath. So you will return home to that heart of his, from which your errors banished you.

SPERONE SPERONI

Speaking of Titian

from

*Dialogue on Love,
'The Mimesis of Love'*

1537

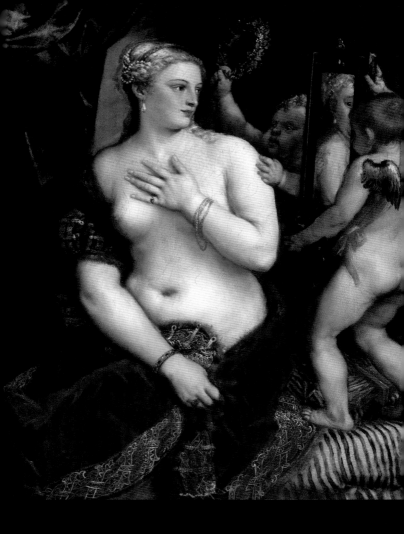

NICOLO GRATIA I do not know how right it is, in speaking of the affairs of love – in your opinion, the best and greatest God – to begin our discussion thereof with portraits and images, which, being no more than dreams and shadows of our being, give us but a poor awareness of the truth we seek.

TULLIA Now what is the world but a beautiful and grand assembly of Nature's portraits? Nature, seeking to paint the glory of God, and being unable to bring it all together in one place, produced infinite species of things, which, each in its own way, resemble it. Thus the world is altogether a likeness of God, made by the hand of Nature. The lover is a portrait, a mirror portrays, and so does a craftsman [*artefice*]; but the painter's portrait, which is only called a portrait [*ritratto*] by common people, is the least good of all: like one that solely represents a man's life by the colour of his skin, and nothing more.

BERNARDO TASSO You do wrong to Titian, whose images are such, and crafted in such a way, that it is better to be painted by him than generated by Nature.

Opposite: Venus with a Mirror, c. 1555

TULLIA Titian is not a painter, and his virtue is not
art, but a miracle, and my opinion is that his colours
are composed of that magical herb which, when
Glaucus tasted it, transformed him from man into
God. Truly Titian's portraits have I know not what
of the divine in them, which just as the sky con-
tains the paradise of souls, so it appears that in his
colours God has placed the paradise of our bodies:
not painted, but become sacred, and glorified by his
hands.

NICOLO GRATIA It is certain that Titian is now a
marvel of our age; yet you praise him in a way that
would astound Aretino.

TULLIA Aretino does not portray things less well in
words than Titian does in colours; I have seen son-
nets written by him after portraits by Titian, and
it is not easy to judge whether the sonnets were
generated by the portraits, or the portraits by the
sonnets. Certainly, both of these together (that is,
the sonnet and the portrait) are a perfect thing: the
former gives voice to the portrait, and in turn the
latter clothes the sonnet in flesh and blood. And I
believe that to be painted by Titian and praised by
Aretino would amount to being regenerated, since

Opposite: Portrait of Jacopo de Strada, 1567-68

men cannot be of such little value, in themselves, if in the pigments and verses of these two they become the noblest and most highly esteemed things.

LUDOVICO DOLCE

Titian

from

The Dialogue on Painting

1557

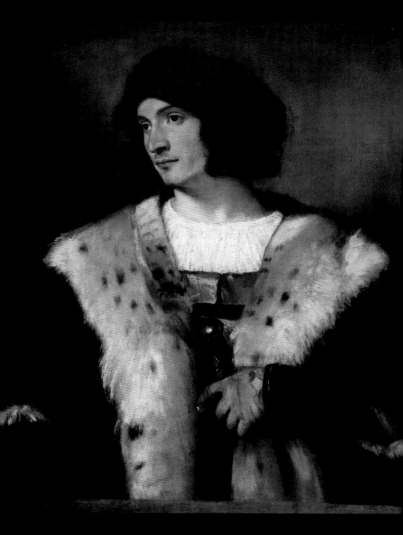

ARETINO It is well known, too, that Nature made him a painter. For being born at Cadore of honourable parents, he was sent, when a child of nine years old, by his father to Venice, to the house of his father's brother (who there attended the care of one of those honourable offices which are always given to citizens), in order that he might be put under some proper master to study painting; his father having perceived in him, even at that tender age, strong marks of genius toward the art.

FABRINI I am pleased to hear any particular in regard to a painter so singularly excellent.

ARETINO His uncle directly carried the child to the house of Sebastiano (father of the elegant Valerio) and of Francesco Zuccato (the only masters in the art of mosaic, by them brought to that perfection which we now see in the best pictures) to learn the principles of the art. From thence he was removed to Gentile Bellini (brother of Giovanni, but much inferior to him), who at that time was at work with this brother in the Hall of the Great Council. But Titian, pushed on by Nature to greater excellence and perfection in the art, could not endure

Opposite: Portrait of a Man in a Red Cap, c. 1510

following the dry and laboured manner of Gentile, but designed with boldness and expedition. Gentile on this told him he would make no progress in painting, because he entirely deserted his manner. Titian, leaving the ignorant Gentile, applied himself to Giovanni Bellini, but not perfectly pleased with his manner, he chose Giorgione da Castelfranco. Designing and painting with Giorgione (as he was called) he became shortly so excellent in his art, that when Giorgione was painting the façade of the Fondaco dei Tedeschi which looks over the Grand Canal, that part already mentioned regarding the Mercerie was given to Titian,[1] who was not quite yet twenty years of age; in which he painted a Judith so admirably, both for drawing and colouring, that on its being opened to public view, and generally thought to be the work of Giorgione, all his friends congratulated him upon it, as far the best thing he ever had done. Giorgione replied with regret, that it was the work of the disciple, who already showed himself greater than his master; and what is more, he stayed at home several days, behaving like a madman, that such a youth could surpass him.

1. c. 1508-9; Venice, Ca' d'Oro (fragments)

Opposite: Judith with the Head of Holofernes (detail), c. 1508-9

LUDOVICO DOLCE

FABRINI I have heard that Giorgione said, that Titian was a painter in his mother's womb.

ARETINO Not long after he was employed to paint a picture for the high altar of the church of the Friars Minor;[1] in which Titian, as yet a youth, painted a Virgin, in oil, ascending to heaven, among many angels that accompany her (with God the father above between two angels). She really appears ascending, with a face full of humility, and her drapery flowing lightly. On the ground are the Apostles, who by diverse attitudes express joy and wonder: they are for the most part larger than life. It is certain this one picture contains at once the grandeur and sublimity [*terribilità*] of Michelangelo, the pleasing grace and perfect beauty of Raphael, together with the the proper colouring of Nature. And yet this was the first public work that he did in oil; he did it in a very short time, and was very young. With all this merit, ignorant painters, and the blind vulgar, who hitherto had seen nothing but the dead and cold pictures of Giovanni Bellini, Gentile, and Vivarini, which were without motion or relief (for Giorgione had

1. *Assumption of the Virgin* (or *Assunta*), 1515-18, still in situ, Santa Maria Gloriosa dei Frari

Opposite: Assumption of the Virgin, 1515-18

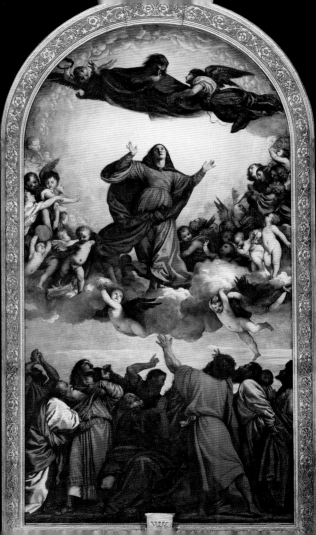

not done as yet any public work in oil, or at most nothing but half-figures and portraits), said all the ill they could of this very picture. At length, Envy growing cool, and Truth by little and little opening their eyes, the people began to wonder at the new manner found out at Venice by Titian, and all the painters from that time studied to imitate him but being put out of their own way, found themselves at a stand. And certainly it may be attributed to a miracle, that Titian, without having yet seen the antiques at Rome, which afforded light to all the excellent painters, with only the little glimmering he had discovered in the works of Giorgione, saw and conceived the idea of perfect painting.

FABRINI It is a proverb of the ancient Greeks, that it is not given to all to go to Corinth, and you have said, to paint well is given but to few.

ARETINO Titian had now acquired a great reputation by his works, that there was not a gentleman in Venice who did not endeavour to procure a portrait or some other picture done by him; and many pictures were bespoken of him; different churches were adorned with his works. In the church of the Friars Minor a picture was done by him, at the

Opposite: Cardinal Pietro Bembo, 1539

instance of the Pesaro family,[1] for the altar (where
the font of holy water is, with a little marble figure
of St. John the Baptist, done by Sansovino), where-
in he painted a Madonna sitting with the Child on
her lap, gently holding up one of its legs, and rest-
ing the other foot on one of her hands. Before her
is St. Peter, of a venerable aspect, turning toward
her with one of his hands on an open book, sup-
ported by the other, and the keys lying at his feet.
There are also St. Francis, and a man in armour
holding a standard, with the portraits of some of
the Pesari, which appear quite like nature. Within
the cloister, in the church of San Niccolò della Lat-
tuga, he also painted a picture for the high altar,[2]
wherein that Saint is the principal figure, dressed
in a golden cope, where the lustre and brilliancy
of gold is discernible, and seems really interwoven.
On one side is St. Catherine, with a slight turn, in
face and every other part truly divine; on the oth-
er, a naked St. Sebastian, beautifully formed, and
with a kind of carnation so like to nature, that it

1. *Pesaro Madonna*, 1519-26, still in situ 2. c. 1512-14 (first version),
c. 1521-22 (second version). Vatican City, Vatican Museums. See p. 50

Opposite: The Pesaro Madonna, 1519-26, in its original altar

seems not painted, but really alive. Pordenone go-
ing to see this St. Sebastian, said, 'I believe Titian
has in this nude really put flesh, not colour'. There
are some other very excellent figures at a distance.
They all appear, as it were, intent on a Virgin, who
is represented above, together with some angels.
Every figure shows a modesty and sanctity which is
inestimable. Besides which, the head of St. Nicho-
las is truly admirable, and full of infinite majesty.

FABRINI I have frequently seen these works. They
are divine, and could not have been executed by
any other hand.

ARETINO In the church of Santa Maria Maggiore he
painted a little picture of St. John the Baptist in the
Desert,[1] of which one may safely believe, that there
never was seen anything more beautiful or better
either for drawing or colouring. In Santi Giovanni
e Paolo, he painted the picture of St. Peter Martyr
fallen to the ground, with the assassin lifting up his
arm to strike him, and a friar in flight with some
little angels in the air, who descend with the crown
of martyrdom.[2] This is in a woody landscape, with

1. c. 1531-32, Venice, Gallerie dell'Accademia 2. 1525-30; lost in a
fire (1867). A copy by Niccolò Cassana (often attributed to Johann
Carl Loth) replaced it. See engraving p. 114

several elder-trees; all having such perfection, that it is much easier to envy than imitate them. The friar seems to fly with a countenance full of fear; it seems as if one heard him cry out; his action is bold, as of one who is really frightened; his drapery is made in a manner of which we have no example. The face of St. Peter has the paleness usually attendant on the faces of persons at the approach of death. He puts forth an arm and hand so well, that one may say, Nature is conquered by Art. I shall not extend my discourse so far as to point out to you the qualities of the invention and drawing and colouring, because they are known to you and everyone else. While Titian was yet young, the Senate gave him an ample provision; and he painted in the Hall of the Great Council I have so often mentioned, the story of Frederick Barbarossa kissing, as I said before, the Pope's feet;[1] and in another part of the hall a battle,[2] where there are many different forms of soldiers, horses, and other remarkable things; and among others, a young woman, who having fallen into a

1. Giovanni Bellini, *Emperor Frederick Barbarossa kneeling before Pope Alexander III outside San Marco*, 1507-16; completed by Titian in 1523; destroyed in 1577 2. *Battle of Rusecco (Valle di Cadore)* or *Battle of Cadore* (sometimes identified as *Battle of Spoleto*), 1538; lost in a fire (1577). Vasari mentioned it as *Battle of Ghiaradadda* (or *Gera d'Adda*)

ditch, in getting out gains the shore by a stretch of her leg so natural, that the leg seems not to be painting but real flesh. You may observe I pass slightly over these works; because only to mention the excellencies, I would need to dwell upon them a whole day. The fame of Titian was not confined within the bounds of Venice, but spread itself diffusedly all over Italy, and made many of the principal nobility desirous of having some of his works; among whom were Alfonso d'Este, Duke of Ferrara, Federico Gonzaga, Duke of Mantua, and also Francesco Maria della Rovere, Duke of Urbino, and many others.[1] Having extended to Rome, it induced Pope Leo to invite him with honourable appointments,[2] that Rome, besides the pictures of Raphael and Michelangelo, might have some of the divine works of his hands. But the great Andrea Navagero, no less acquainted with painting than with poetry (particularly in Latin, in which he was so excellent), foreseeing that in losing him Venice would be despoiled of one of her greatest ornaments, prevailed with him not to go. His fame also extended into France; nor did King François fail to solicit him with high offers

1. An expanded list was published by the architect Sebastiano Serlio, see p. 13 2. Possibly 1513

to come to him; but Titian would not leave Venice, whither he had come when a child, and had chosen it for his country. Of Charles the Fifth I have spoken to you already; so that I conclude, that there never was a painter who was so much esteemed by princes, as Titian always was. See the force of supreme excellence!

FABRINI Let who will say to the contrary, merit never can rest long concealed; and every man possessed of it, if he governs himself with prudence, is the architect of his own fortune.

ARETINO Certainly, Fabrini, one may say with the greatest truth, that there never was any painter who did greater honour to his profession than Titian. For knowing his own merit, he always esteemed his pictures of the highest value, not caring to paint unless for great persons, and such as were able to reward him properly for them. It would be too long to recount the portraits done by him, which are of such excellence, that life itself scarce seems more alive, and all of them kings, emperors, popes, princes, or other great men. There never was a cardinal or other grandee in Venice that did not go to Titian's house to see his works, and sit to him. I should also be too prolix, if I was to discourse of his pictures, which are in the chambers of the Council

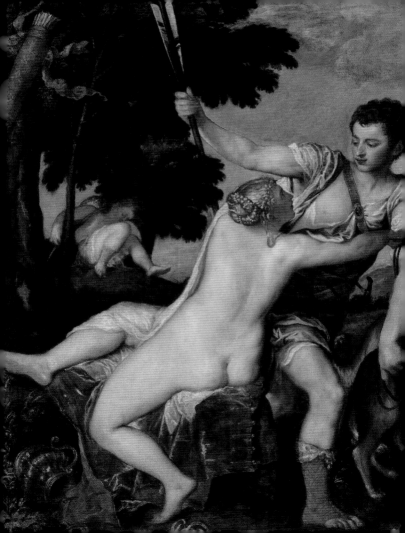

Venus and Adonis, c. 1555

Hall of the Doge's Palace,[1] and of the many others done by him for the Emperor and the King of England;[2] such as the picture of the Trinity,[3] the weeping Madonna,[4] of Tityus, of Tantalus, of Sisyphus,[5] of Andromeda,[6] and of Adonis[7] (after which an engraving will be published soon)[8] and of other narrative stories and mythological fables; works equally divine, whether considered with respect to drawing, colouring, or invention. But I will restrain and moderate myself in his praises, both as he is my friend and comrade, and as he must be blind who cannot see the sun. I must not omit mentioning, that Titian painted at Mantua for the Duke Federico, the twelve Cæsars,[9] taken partly from medals, and partly from antique marbles. They are of such exquisite

1. Lost in a fire (1574). See also Vasari 2. See Aretino's letter, p. 139 3. *The Glory*, 1551-54, Madrid, Prado 4. One of the two versions of the *Virgin Dolorosa*, Madrid, Prado: cat. nos. P443 (1554); P444 (1555) 5. 1548-49, cycle of *Four Furies*, lost. *Tityus* (perhaps a replica of c.1565) and *Sisyphus* in Madrid, Prado. *Ixion* and *Tantalus* (perhaps by Michiel Coxie) lost in a fire (1734) 6. 1554-56; London, Wallace Collection 7. 1554-55; Madrid, Prado 8. 1559, engraved copy by Giulio Sanuto 9. *Eleven Cæsars*, 1536-39, lost in a fire (1734). Bernardino Campi added a twelfth Cæsar (*Domitian*, 1562) and copied the whole series (Naples, Museo di Capodimonte); engraved copies also by Ægidius Sadeler

Opposite: The Virgin Dolorosa with her Hands apart, 1555

perfection, that vast numbers go to that city only to see them, thinking that they see the Cæsars themselves, not pictures.

FABRINI I know well that few of the lower rank can boast of having any portrait or other picture done by him.

ARETINO Our Titian is, then, in painting divine and unequalled, nor ought Apelles himself, were he alive, to disdain to do him honour. But besides his wonderful excellence in painting, he has many other qualities worthy of the highest praises. In the first place, he is extremely modest, never wounding invidiously any painter's character, but speaks honourably of every one who deserves it. He also is an eloquent conversationalist; of a most perfect intellect and judgment in all things; of a gentle and placid temper; affable; of the most delicate manners; insomuch that whoever once speaks to him must always love him.

FABRINI All this is perfectly true; and as I think nothing more remains for you to say on this subject, we may conclude, that although there are at present many excellent painters, those three hold the first rank, namely Michelangelo, Raphael, and Titian.

Opposite: Ranuccio Farnese, 1542

List of illustrations

All oil on canvas unless otherwise noted

p. 1: Detail from Diana and Actæon, 1556-59,
National Gallery, London and National Galleries, Scotland

p. 2: St Margaret and the Dragon, c. 1565, 209 x 103 cm,
Museo Nacional del Prado, Madrid

p. 4: Noli me Tangere, c. 1514, 110 x 91 cm, National Gallery, London

p. 6: Venus Anadyomene, c. 1520, 76 x 57 cm,
National Galleries, Scotland

p. 8: Philip II offering the Infante Ferdinand to Victory, 1573-75,
335 x 274 cm, Museo Nacional del Prado, Madrid

p. 11: Pietro Aretino, c. 1537, 101 x 85 cm, Frick Collection, New York

p. 14: Portrait of a Woman ('La Schiavona'), c. 1510-12, 119 x 96 cm,
National Gallery, London

pp. 18-19: Bacchus and Ariadne, 1520-23, 176 x 191 cm,
National Gallery, London

p. 22: The Tribute Money, 1560-68, 112 x 103 cm,
National Gallery, London

pp. 26-27: Diana and Callisto, 1556-59, 187 x 204 cm,
National Gallery, London and National Galleries, Scotland

pp. 29: Portrait of Titian, woodcut illustration from original edition
of Vasari's *Lives*, published 1568

p. 30: The pastoral concert, c. 1511, oil on panel, 105 x 137 cm,
Musée du Louvre, Paris

p. 35: Portrait of a Man with a Quilted Sleeve, c. 1509, 81 x 66 cm,
National Gallery, London

p. 38: Andrea Andreani (After Titian), Section E: Christ riding on a triumphal
cart, from The Triumph of Faith (also known as The Triumph of Christ).
Lithographic copy (1836) of 17th century woodcut, 398 x 27 cm,
Metropolitan Museum of Art, New York

p. 41: The Miracle of the Speaking Babe, fresco, 1511, 340 x 355 cm,
Confraternity of St Anthony, Padua

p. 42: Doge Francesco Venier, 1554-56, 113 x 99 cm,
Museo Nacional Thyssen-Bornemisza, Madrid

p. 45: The Bacchanal of the Andrians, c. 1519-21, 175 x 193 cm,
Museo Nacional del Prado, Madrid

p. 47: The Worship of Venus, 1518-19, 172 x 175 cm,
Museo Nacional del Prado, Madrid

p. 50: Madonna with Child and Saints (called Madonna of the Frari), c. 1521-22,
oil on wood transferred onto canvas, 388 x 270 cm,
Vatican Museum, Rome

p. 53: St John the Baptist in the Desert, c. 1531-32, 201 x 134 cm,
Galleria dell' Academia, Venice

p. 55: Doge Andrea Gritti, c. 1546-50, 133 x 103 cm,
National Gallery of Art, Washington, DC

pp. 58-59: Presentation of the Virgin at the Temple, 1534-38, 345 x 775 cm,
Gallerie dell'Accademia, Venice

p. 60: Saint John the Almoner, c. 1550, 229 x 156 cm,
Church of San Giovanni Elemosinario, Venice

p. 63: Portrait of Alfonso d'Avalos, Marquis of Vasto, in Armour with a Page,
1533, 110 x 80 cm, J. Paul Getty Museum, Los Angeles

p. 64: Federico Gonzaga, 1st Duke of Mantua, 1529, oil on panel, 125 x 99 cm,
Museo Nacional del Prado, Madrid

p. 66: Flora, 1516-18, 79 x 63 cm, Galleria degli Uffizi, Florence

pp. 68-69: Venus of Urbino, c. 1533-38, 119 x 165 cm,
Galleria degli Uffizi, Florence

p. 71: Resurrection Polyptych, 1519-22, 278 x 122 cm,
Santi Nazaro e Celso, Brescia

p. 74: Ecce Homo, 1547, oil on slate, 69 x 56 cm,
Museo Nacional del Prado, Madrid

pp. 78-79: Danaë, 1545, 120 x 172 cm,
Museo Nazionale di Capodimonte, Naples

p. 81: The Emperor Charles V at Mühlberg, 1548, 335 x 283 cm,
Museo Nacional del Prado, Madrid

p. 82: Philip II, 1551, 193 x 111 cm, Museo Nacional del Prado, Madrid

p. 85: The Glory, 1551-54, 346 x 240 cm, Museo Nacional del Prado, Madrid

p. 86: Tityus, c. 1565, 253 x 217 cm, Museo Nacional del Prado, Madrid

pp. 90-91: Diana and Actæon, 1556-59, 184 x 202 cm,
National Gallery, London and National Galleries, Scotland

p. 93: The Martyrdom of Saint Lawrence, c. 1548-57, 493 x 277 cm,
Church of I Gesuiti, Venice

p. 94: The Penitent Magdalene, 1555-65, 108 x 94 cm,
J. Paul Getty Museum, Los Angeles

pp. 102-3: The Entombment, c. 1562-72, 130 x168 cm,
Museo Nacional del Prado, Madrid

p. 106: Two Satyrs in a Landscape, c. 1505-10,
pen and brown ink with white gouache highlights on paper, 21.6 x 15 cm,
Metropolitan Museum of Art, New York

pp. 110-11: Sacred and Profane Love, c. 1515-16, 118 x 279 cm,
Galleria Borghese, Rome

p. 114: Death of St Peter Martyr, after Titian, c. 1560, engraving,
40 x 27 cm, Metropolitan Museum of Art, New York

p. 119: Portrait of Francesco Maria della Rovere, c. 1537,
114 x 103 cm, Galleria degli Uffizi, Florence

p. 120: Portrait of Eleonora Gonzaga, Duchess of Urbino, c. 1537,
114 x 103 cm, Galleria degli Uffizi, Florence

p. 124: The Allocution of the Marquis del Vasto to his Troops, c. 1540-41,
223 x 165 cm, Museo Nacional del Prado, Madrid

p. 128: Vincenzo Cappello (painted with workshop assistance), c. 1540,
141 x 118.1 cm, National Gallery of Art, Washington, DC

p. 131: Clarissa Strozzi, 1542, 115 × 98 cm, Gemäldegalerie Museum, Berlin

p. 132: Pope Paul III, 1543, 106 x 85 cm,
Museo Nazionale di Capodimonte, Naples

p. 142: An Allegory of Prudence, c. 1560-70, 75 x 68, National Gallery, London

p. 146: Venus with a Mirror, c. 1555, 124 x 105 cm,
National Gallery of Art, Washington, DC

p. 149: Portrait of Jacopo de Strada, 1567-68, 125 x 95 cm,
Kunsthistorisches Museum, Vienna

p. 152: Portrait of a Man in a Red Cap, c. 1510, 82 x 71 cm,
The Frick Collection New York

p. 155: Judith with the Head of Holofernes (detail), c. 1508-9, fresco,
Galleria Georgio Franchetti alla Ca d'Oro

p. 157: Assumption of the Virgin (or Assunta), 1515-18, oil on panel, 690 x 360 cm,
Santa Maria dei Frari, Venice

p. 158: Cardinal Pietro Bembo, 1539, 94 x 76 cm,
National Gallery of Art, Washington, DC

p. 161: Pesaro Madonna, 1519-26, 488 x 269 cm,
Santa Maria Gloriosa dei Frari, Venice

pp. 166-67: Venus and Adonis, c. 1555, 161 x 196 cm,
J. Paul Getty Museum, Los Angeles

p. 169: The Virgin Dolorosa with her Hands apart, 1555, oil on marble, 68 x53
cm, Museo Nacional del Prado, Madrid

p. 170: Ranuccio Farnese, 1542, 89 x 73 cm,
National Gallery of Art, Washington, DC

Photography on pp. 2, 4, 6, 8, 14, 18-19, 22, 26-27, 29, 30, 35, 41, 42, 45, 47, 64,
66, 71, 74, 78-79, 81, 82, 85, 85, 90-91, 102-3, 110-11, 120, 124, 131, 142, 149, 155
and 169 courtesy Wikimedia Commons; on pp. 11 and 152 © Frick
Collection; on pp. 39, 106 and 114 courtesy Metropolitan Museum
of Art; on pp. 50, 68-69, 119 and 132 © Bridgeman Art Library;
on pp. 53, 58-59, 60 and 93 © Cameraphoto; on pp. 55,
128, 146, 158 and 170 courtesy National Gallery of Art;
on pp. 63, 94 and 166-67 courtesy J. Paul Getty
Museum; on pp. 157 and 161 © Frari Photo
Archive, with special thanks to the
Basilica di Santa Maria
Gloriosa dei Frari,
Venice

© 2019 Pallas Athene

Published in the United States of America by the J. Paul Getty Museum, Los Angeles
Getty Publications
1200 Getty Center Drive, Suite 500
Los Angeles, California 90049-1682
www.getty.edu/publications

Distributed in the United States and Canada by the University of Chicago Press

Printed in China

ISBN 978-1-60606-587-7

Library of Congress Control Number: 2018953953

Published in the United Kingdom by Pallas Athene
Studio 11A, Archway Studios
25–27 Bickerton Road, London N19 5JT

Alexander Fyjis-Walker, *Series Editor*
Anaïs Métais, *Editorial Assistant*

Giorgio Vasari's *Life of Titian* was first published in 1568. The translation here is by Carlo Corsato and Frank Dabell, based on the one by Gaston de Vere published in 1915. We are also publishing, for the first time in English, the colourful marginal comments to Vasari scribbled in his copy by the Bolognese Baroque painter Annibale Carracci (1560-1609) (identified as AC in the text). The translation is by Carlo Corsato and Frank Dabell. Francesco Priscianese's letter was first published by him in 1540; our translation is by Frank Dabell and Carlo Corsato. Aretino published his letters variously between 1538 and 1550; they are available in English for the first time, our translation is by Frank Dabell and Carlo Corsato. Speroni's *Dialogue on Love* was written in 1537 and published by him in 1542; the translation is by Frank Dabell. Ludovico Dolce's *Dialogue on Painting* was published in 1557; the translation is by Carlo Corsato, based on the one by W. Brown published in 1770.

Front cover: Titian (Tiziano Vecellio), *Self-Portrait*, ca. 1562. Oil on canvas, 96 x 75 cm (37 13/16 x 29½ in.). Gemäldegalerie, Staatliche Museen, Berlin. Photo: Erich Lessing / Art Resource, NY